IMAGES
of America

STRATFORD

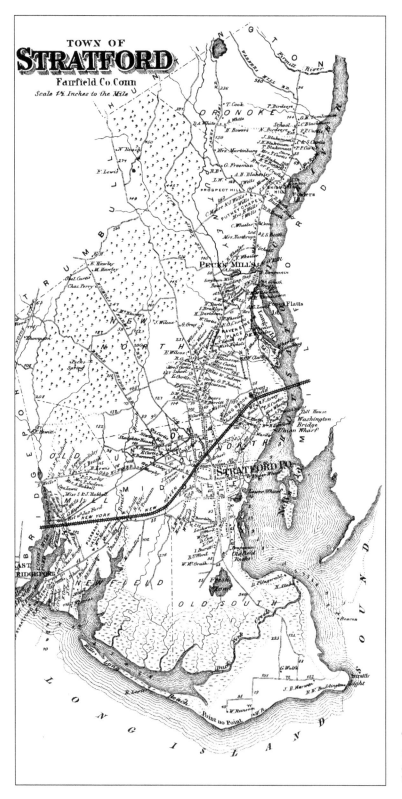

This map is from the *Beers Atlas of New York and Vicinity* (1867).

IMAGES
of America

STRATFORD

John D. Calhoun, Lewis G. Knapp, and Carol W. Lovell

ARCADIA
PUBLISHING

Published by Arcadia Publishing
Charleston, South Carolina

Library of Congress Catalog Card Number: 9962497

For all general information contact Arcadia Publishing at:
Telephone 843-853-2070
Fax 843-853-0044
E-mail sales@arcadiapublishing.com
For customer service and orders:
Toll-Free 1-888-313-2665

Visit us on the Internet at www.arcadiapublishing.com

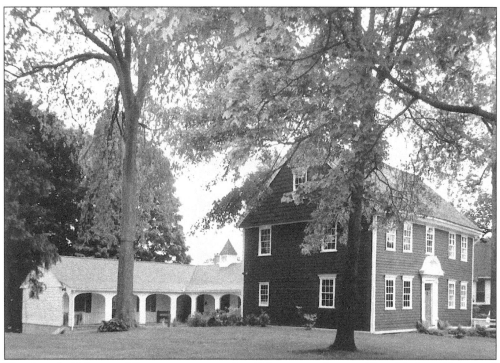

The Stratford Historical Society maintains the 18th-century Captain David Judson House and Catharine B. Mitchell Museum on Academy Hill, the site of one of the earliest house lots in Stratford. Founded in 1925, the society continues to preserve and share artifacts and history of the town of Stratford.

CONTENTS

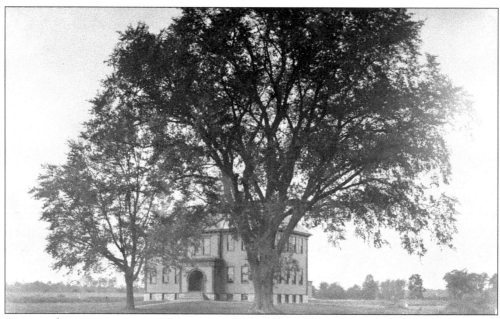

As recently as a century ago our streets were shaded by a canopy of chestnut trees and elms. Centuries-old wineglass elms with trunks 5 feet in diameter stood 75 to 100 feet high, in park-like splendor. This elm, in front of Sedgewick School, reminds us of the beauty now gone, felled by chestnut blight and Dutch elm disease.

The authors thank the following for their help with this project:
Marie Blake, Dorothy Bobko, Joseph Buchino, Raymond Cable,
Gloria Duggan, Rick Heyse, Margaret Jacaruso,
Howard Lounsbury, and Cynthia Russell.

INTRODUCTION

Vintage photographs allow us to view history visually and fill in the gaps left open by history books. Several Stratford histories have been written; however, this album of images in the town of Stratford gives a perspective beyond that of written word—it *shows* us how the town has evolved over the last 140 years.

Pictorial records of the town appear in a variety of mediums, which include maps, pencil sketches, and paintings. The first recorded photograph was taken in 1859 when Lewis Russell wrote in his diary (referring to some of the important persons in town), "Pa, Captain Sands, Captain Sterling, Mr. Gilbert, Mr. Sedgewick, Mr. Olney, and Captain Benjamin went down to the [Empire] ambrotype gallery with several others and all stood in a group and had their likeness taken."

We owe our best early pictures to Frederick Converse Beach, one of the first amateur photographers of note in America. Beach began his interest in photography when ambrotypes—images created through a wet plate collodion process—were still being produced. Even before graduating from Yale in 1868 he set up his first photography shop in a shed at his father's house on Elm Street. A personal friend of George Eastman, Beach helped found the Camera Club of New York in 1884 and then began and edited *American Photography* magazine.

Another prominent amateur photographer was A. Bedell Benjamin. Like Beach, Benjamin was able to indulge in this expensive hobby, recording Stratford scenes throughout the town. He specialized in lanternslides, and accumulated the finest collection of steamboat slides in existence, which are now housed at the Stratford Library. Other early local photographers included Ada Houghton, Elbert Hubbell, Lucius Judson Jr., Edward Wells, and his sister, Sallie D. Wells.

In 1909 young William Howard Wilcoxson received a camera as a laundry-soap premium and began a hobby that lasted all his life. From glass-plate negatives to cellulose film to colored film, many of our 20th-century photographs are his.

More recent photographs were taken by Bob Burns, Ruth Tabor, Lew Knapp, and others. Most of the images presented here are from the files of the Stratford Historical Society. All contribute to the lesser-known history of Stratford and supplement our history books.

We hope you enjoy them and learn from them!

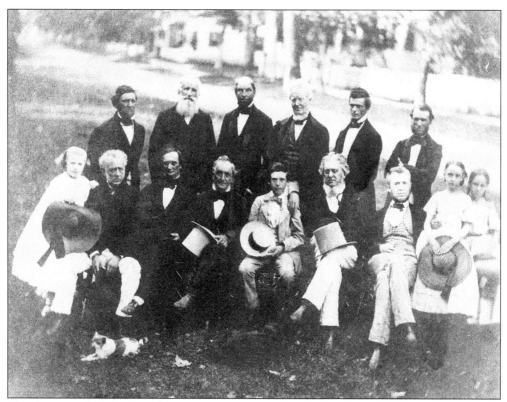

The first recorded photograph in Stratford, taken in 1859, was documented by Lewis Russell in his diary. This is one of two known versions of the event, which took place at the corner of Main Street and Broad Street.

One

LIFE IN THE CENTER

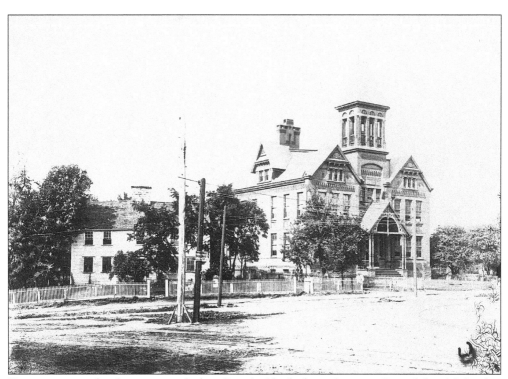

Ten one-room schools were retired when Stratford built the eight-room Consolidated School in 1885. Within nine years it was too small and another new school was built. In 1909 four rooms were added, and a flood of new brick schools followed. We now have 14 schools, and this old graded school located at the Center (following a serious fire in 1921) is now the Stratford Board of Education building.

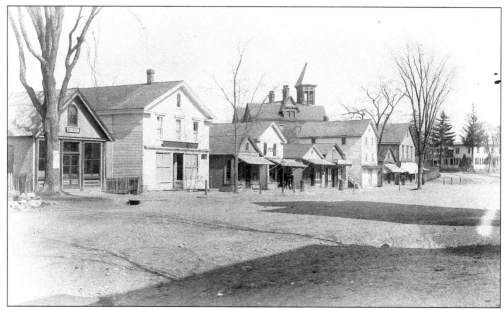

The east side of Stratford Center is a row of small wooden stores in this c. 1890 view looking south from the railroad crossing. The businesses are, from left to right, the post office, Whiting's Meat Market, Moore's Dry Goods, Beardsley's Grocery, Strassburger's Barber Shop, a newsroom, St. John's Drug Store, and Plumb and Bartram's Grocery and Grain Supply. Main Street is unpaved; in the spring, the mud became ankle deep.

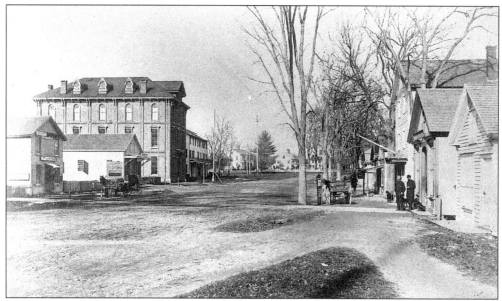

Several more small businesses are visible here on the west side of Main Street in the Center in 1890, including a shoemaker shop, the L.H. Todd & Co. hardware store (later Lovell's), the new town hall (purchased from the Masons for $12,000 in 1887), and the Boothe Block (once a hoopskirt factory and later Newton Reed's grocery and meat market). The large flagpole in the distance marks the railroad grade crossing.

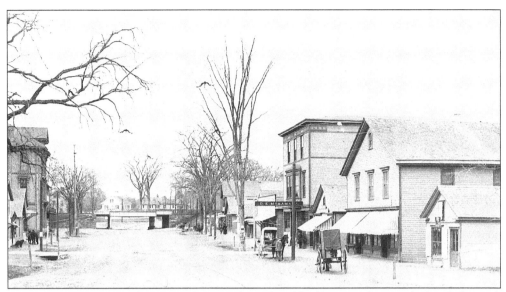

By 1894 the Center had begun to change. The railroad had become four-tracked and elevated. The traction company extended its tracks under the new viaduct and north to Paradise Green. Since 1892, iron stoves in the L.H. Todd Co. warmed the local bigwigs who met there to pontificate over politics. This informal gathering was known as the "Stove Club."

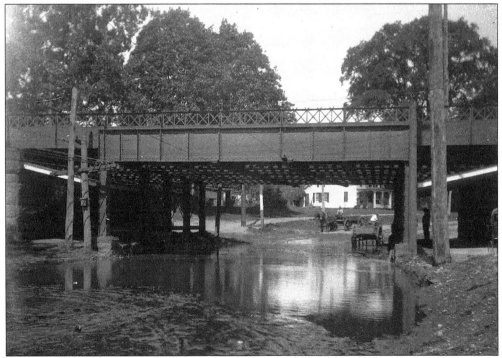

When the railroad was re-graded in 1894, farmers complained that the tracks were too low to allow their hay wagons to pass beneath. Main Street was re-graded, creating downgrades to the viaduct. The result was flooding during every large storm. When the street was later paved, the problem worsened and, even though large pumps are now in operation, floods at the Main Street viaduct have persisted for more than a century.

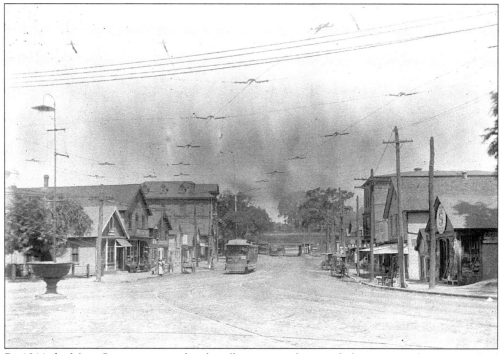

By 1911 the Main Street was paved, sidewalks were in place, and electricity and city water had arrived. This street car from Paradise Green or Derby will turn right to Bridgeport over Stratford Avenue. The second trolley, from Bridgeport via Barnum Avenue, will turn left toward New Haven. The flagpole was replaced by a cast-iron fountain and horse-watering trough.

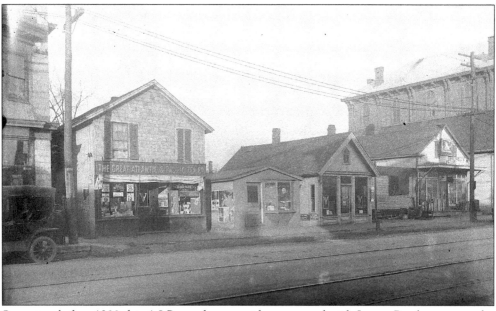

Sometime before 1920 this A&P, on the west side, competed with Logan Brothers across the street. The first chain stores had arrived in Stratford Center.

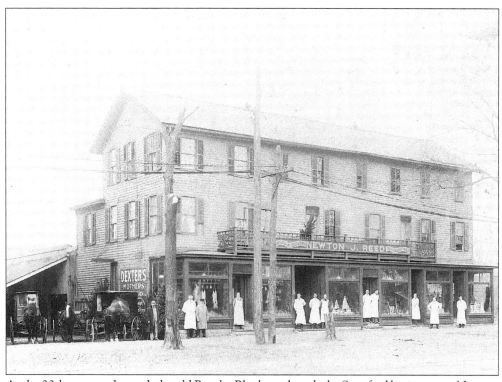

As the 20th century dawned, the old Boothe Block was bought by Stratford businessman Newton Reed. The meat market was later run by the Johnsons. The LaReau family lived upstairs. Two streets in town, Newton and Reed, were named for the owner. The entire block was torn down to make way for I-95 in 1955–56.

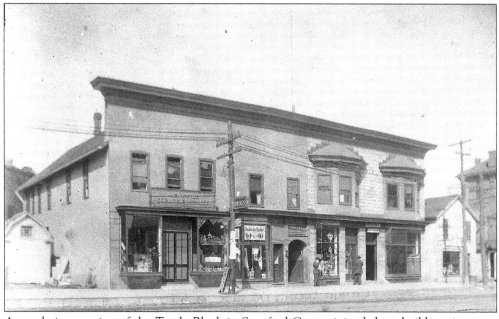

An early incarnation of the Tuttle Block in Stratford Center joined three buildings into one with a new facade.

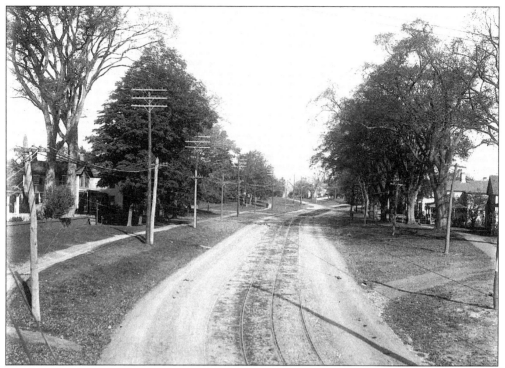

Main Street north of the railroad was lined with ancient elms whose trunks measured 4 feet in diameter. In the distance is North Parade, once the home of the 17th-century Train Band No. 2. It was later the site of Union School.

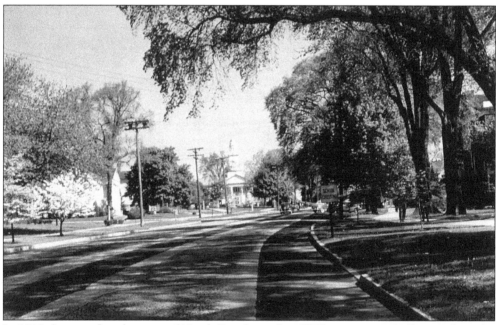

In 1923 the town bought more of North Parade, and in 1937 a new town hall opened on the site. Buses had replaced the trolleys by this time, but the rails were still in place. Stately elms graced the right-of-way, and dogwoods had been added. Main Street was at its most beautiful.

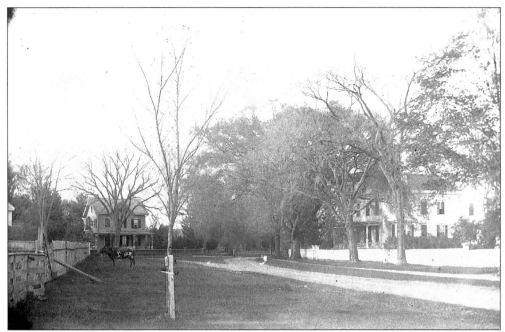

The Elm Street/East Broadway corner was truly pastoral. An 1893 news article stated, "People driving in the lower part of town are annoyed considerably by having cattle pastured in the street. They are fastened by rope which runs from fence to fence, causing people in vehicles to stop and drive the cows back so they can go by, as the rope is generally stretched across the street."

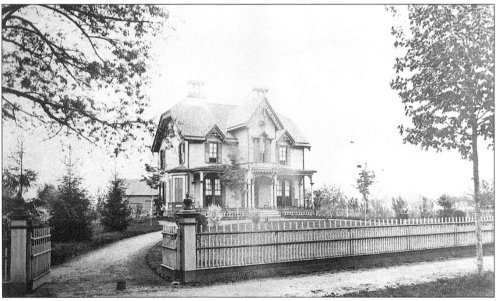

When Stratford Center was the hub of Stratford, most of the prominent businessmen lived within walking distance. This elegant American-Gothic house was built c. 1855 on East Broadway, the road to the Washington Bridge. The open space around the building is nothing like the neighborhood today at the corner of Blakeman Place. The fence is gone and the trim has been reduced, but the house still bears evidence of its early glory.

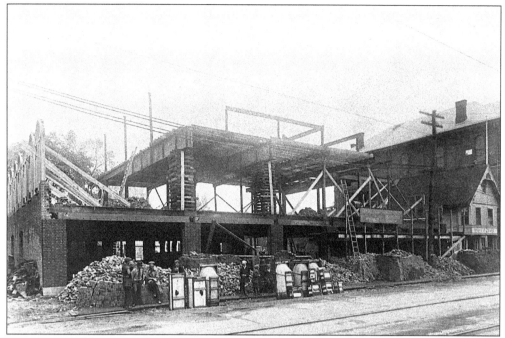

In 1920 Harold C. Lovell took a chance and built the biggest building in town. Local businesses—St. John's Drug Store, the A&P, the shoe store, and the H.C. Lovell Co. hardware store—abandoned their old quarters for a new modern three-story home.

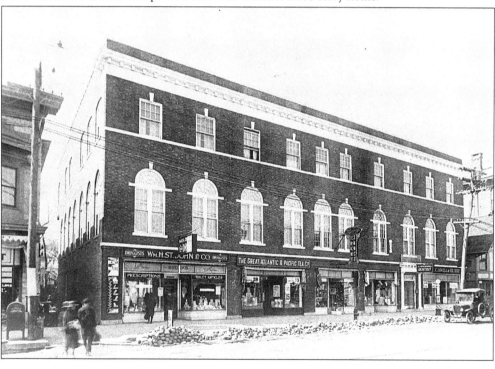

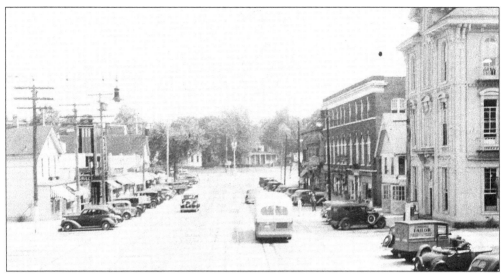

In May 1937 the Connecticut Railway and Lighting Company replaced its last trolleys with buses. The promise at the Center was "a bus every six minutes, and, in rush hour, every three."

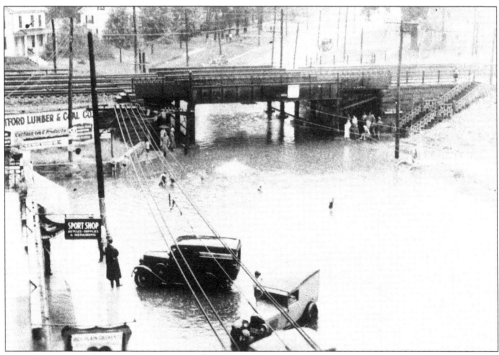

This late 1930s flood at the viaduct shut down the Center. Passengers from a local train were stranded. The Stratford Lumber Company sign (later Burritt's) was unread. The Sport Shop and the tailor waited for customers.

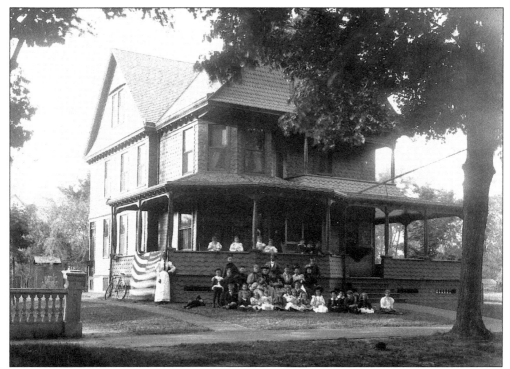

This elegant 1890s Queen Anne house on East Broadway looks as though it might have been built for an important family—and it was. In 1911, Sheriff Charles E. Stagg lived here. In 1940 Bridgeport Post Business Manager T.A.D. Weaver did. The group of young children posing on the lawn *c*. 1910 foretold a future use; for the last 60 years it has been the Helen King Reynolds private kindergarten.

Note that the Knell House behind the ladies is well kept up in this *c*. 1900 view looking south on Elm Street toward Sandy Hollow. By this time Jim Meachen had built his house on the site of the first meetinghouse, the Old South School had been sold and removed, and the 120-foot-wide right-of-way had only a single narrow traffic lane.

Frederick C. Beach photographed his estate sometime after 1907. In the foreground is the "Yellow Cottage," the first home of his father in Stratford. Next is the Beach Mansion, built by Captain Dowdall in 1826 but called the Phelps House after a later owner. It was extensively restored by Beach in 1907. Beyond is the large gambrel-roofed home built by Gen. Matthias Nicoll c. 1786, which was occupied by Beach's son Stanley.

In 1892 the town provided street lamps wherever nearby residents agreed to supply the oil and tend to the lamps. Here we see the lamp that Mr. Charles Curtis kept filled and lit for many years at his own expense. It was the only street lamp in town c. 1910.

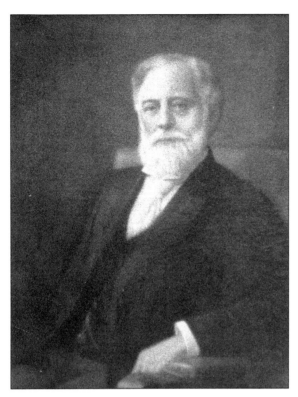

Birdseye Blakeman, a descendant of Rev. Adam Blakeman, the first minister of Stratford (1639), and of Deacon Birdseye, was a publisher of school books and the president of the American Book Company in New York City. He never forgot his native town and his generosity made possible a magnificent library in 1896.

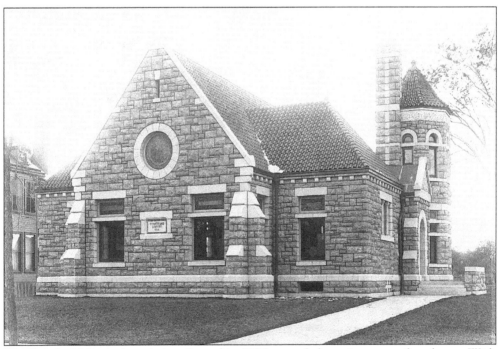

The Stratford Library Association, formed in 1885, struggled to raise money for a home. With funds from Birdseye Blakeman, this granite building was begun in 1894 and opened in 1896. Miss Fannie Russell was head librarian from 1896 to 1958.

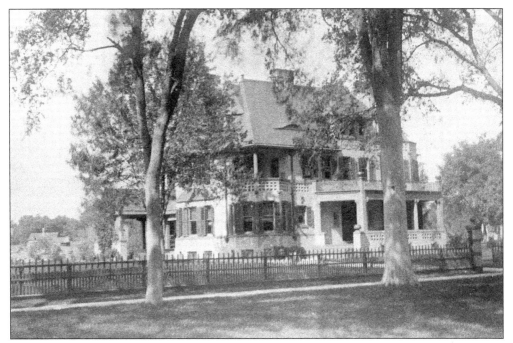

In 1886 wealthy John W. Sterling had this mansion built for his mother and sisters. Although his brother-in-law, architect Rufus Bunnell, was to live in the house, Sterling hired nationally known Bruce Price to design it.

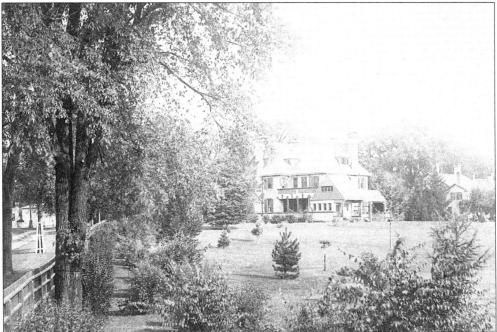

This early view of the Sterling House shows plantings done by the firm of Frederick Law Olmstead, designers of Central Park in New York City. The original wooden fence divides the property from a town-owned right-of-way south of the Congregational church. The wooden enclosure surrounding the young tree near the road protected it from horses.

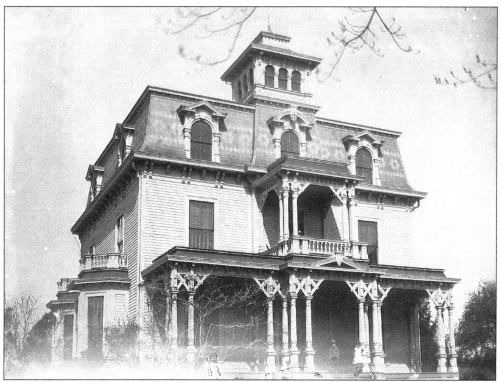

When Edward Allen Powers built this house with his inheritance in 1881, he settled down to the life of a gentleman. When the money ran out, the house passed through several owners before becoming the first American Legion headquarters, the office of the *Stratford News*, and the post office.

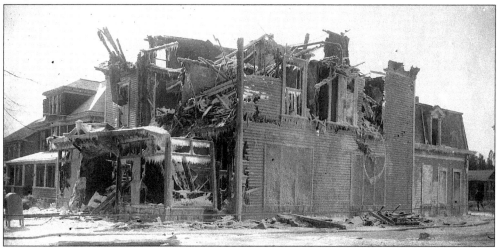

In 1922 the Stratford Post Office relocated from the Tuttle Block in Stratford Center to the Powers House on Main Street. On January 26, 1924, a fire (possibly from a news reporter's cigarette) burned down the building. Since then the post office has had several homes, including the first floor front of the old town hall (until 1949), the brick office building at Main and Broadbridge (until 1963), and the building at Main and Hurd (since 1963). The post office also has a new customer store on Barnum Avenue Cut-off.

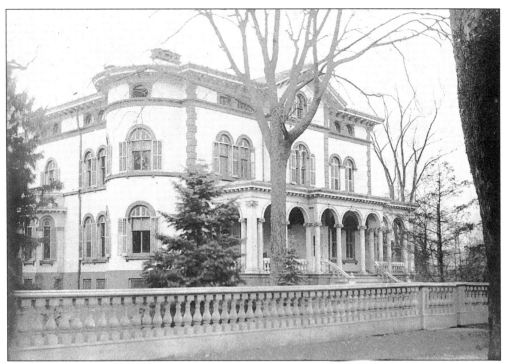

Frederick Benjamin built this Italianate brownstone mansion on West Broad Street in 1864. His son Bedell and Bedell's wife, Jessie, lived on the estate for 48 years.

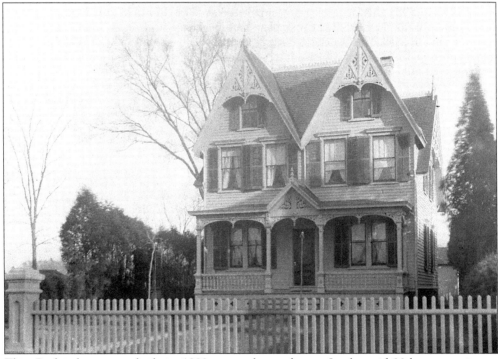

This Gothic house was built in 1880 as an elegant home. In the mid-20th century it was extensively changed and converted to an office building on busy Main Street.

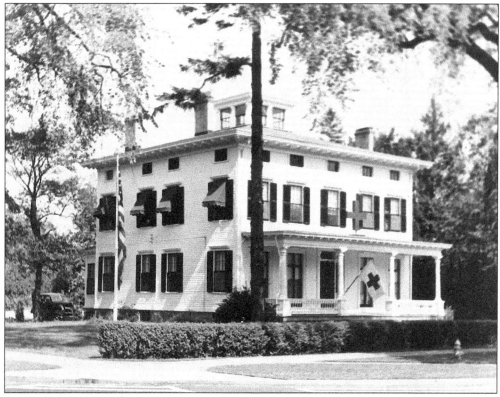

From 1945 to 1983 this mansion on Main Street at West Broad (South Parade) was the headquarters of the Stratford Red Cross. New York merchant William A. Tomlinson had the mansion built in 1859. The ownership passed to banker William Booth, then to George Talbot, and finally to Judge Howard J. Curtiss. It served as a rooming house during World War II. It has been restored and is now Pistey's Funeral Home.

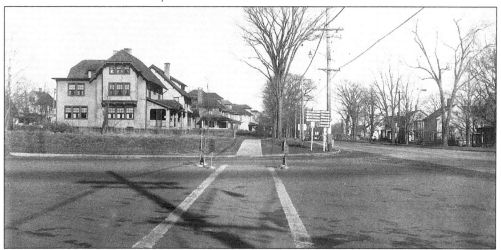

Looking north on Main Street from the cut-off in the early 1930s, we see a group of new stucco homes on the left and 18th-century homes on the right. Most of the homes are now long gone, and so is the rotary platform where Sergeant Geary used to stand to rotate a stop-go sign during rush hours. The intersection is still occasionally called "the rotary."

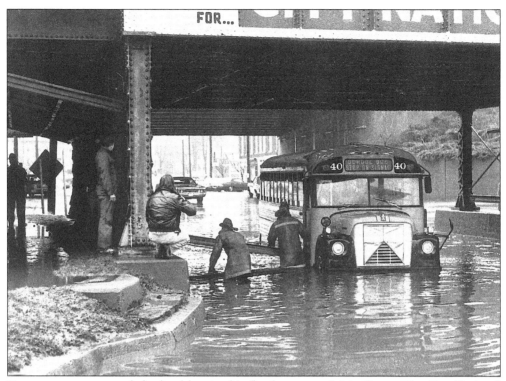

Firemen empty a stranded school bus in this flood scene on Main Street. The City National Bank sign barely visible on the overpass dates the picture to the 1970s. Shortly after this, drain pumps were finally installed.

In 1932 the highway department opened a new road to the east across the fields from Main Street to Washington Bridge and called it Barnum Avenue Cut-off. The cut-off became part of Route 1-A. This view from a seven-way intersection at Nichols Avenue shows 1-A heading eastward to the left and Essex Place (once Barnum Avenue) to the right. Behind the photographer are Booth Street and Barnum Avenue.

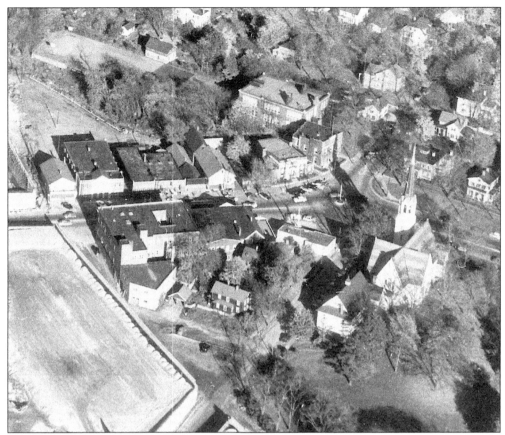

This early 1950s photograph, taken during construction of the turnpike (lower left), includes much of Stratford Center. The Congregational church spire is visible at center right. How many other landmarks can you identify?

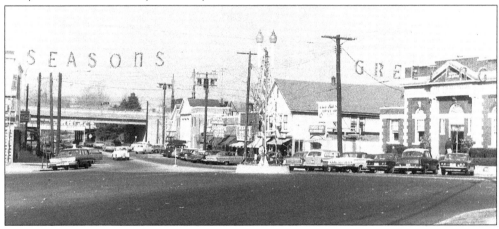

Christmas lights decorate the Center in the mid-1960s. A new turnpike bridge stretches across the road. By this time Al Pickus' movie theater had a Federal-style brick front, the small wooden stores had given way to a one-story concrete block building, and the large wooden building housed a florist shop. The pylon at the intersection, formerly a flag pole or watering trough, was being used for a pair of lights.

Two

Business and Industry

This 1890 photograph of Elias Wells' home and store shows a typical Stratford homestead. The lean-to (saltbox) house faced east on Main Street, between Esek Lane (Essex Place) and Egypt Lane (North Avenue). The ancient elm was probably planted by Wells' grandfather when the house was built in 1735. The horse and phaeton belong to the photographer, Frederick Beach.

When Curtis Place was laid out before 1920, Wells' centuries-old homestead came down, and the store was moved around the corner onto a concrete block foundation on the new street.

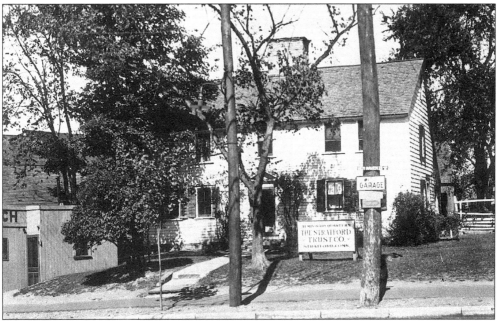

As the Center expanded, the old Dayton House became a tearoom; in 1915 Lucius Booth's fish market was removed to add dignity to the new Stratford Trust Company's office in the house. Soon afterwards, the house itself came down, replaced by the bank's brick building. Preservationists fought the Dayton House removal; they even enlisted the first lady, Mrs. William Howard Taft, for their cause, but Elliott Peck and progress prevailed.

28

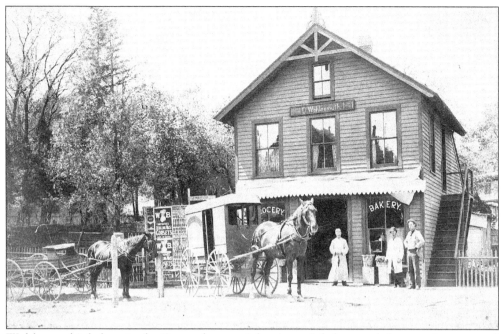

Wohlenmuth's bakery in the Center became John Assum's bakery and then was incorporated into the Tuttle Block as a drugstore.

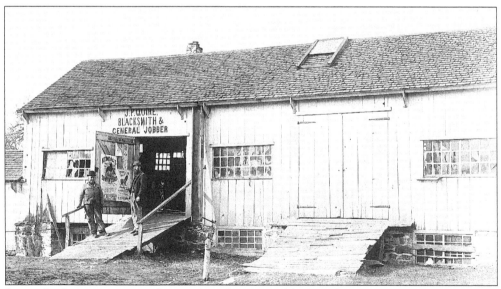

Jeremiah Quire was one of several 19th-century blacksmiths in town. They worked as wheelwrights for the carriagemakers and as farriers for the horses. Quire's shop stood near the northwest corner of Main Street and Stratford Avenue, west of Leavitt's house.

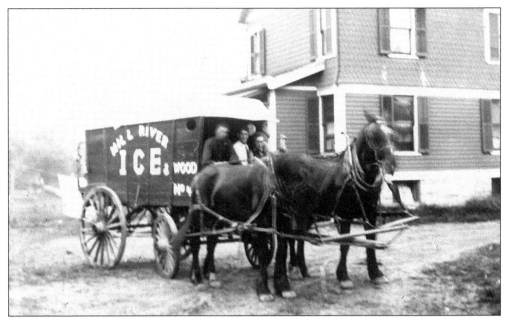

When the 20th century began, the Housatonic River was covered by a foot of ice each winter and local ponds furnished blocks of ice for summer refrigeration. The huge icehouse at Peck's Mill Pond was filled with sawdust-covered blocks of ice each winter, and all summer the Mill River Ice and Wood Company delivered to households through the town. Cardboard signs in windows told the delivery team what price block to put into the icebox.

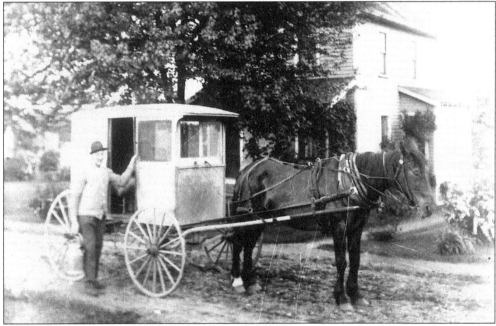

When cars were scarce and phones were non-existent, home supplies arrived by horse-drawn delivery wagon. Bread from Finger's Bakery, milk from Harry Wilcoxson, meat from Johnson's market, and groceries from several vendors reached customers each day. Periodically the fruit and vegetable man came by, and occasionally the ragman and the scissors sharpener appeared.

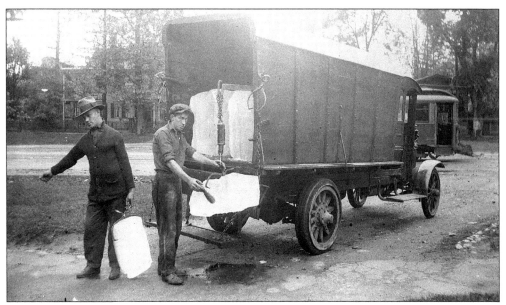

By 1916 Webb Brothers turned in their ice wagon for a modern truck, seen here on Main Street at the Center. The deliveryman seems to be carrying a 50-pound piece of ice toward the Congregational church.

Since 1676, when James Blakeman built a sawmill on Farmill River, 11 mills have been scattered along the river and its branches including a gristmill, paper mill, sawmill, cider mill, sorghum mill, and stump-joint factory. The last mill at the dam site was Roberts' paper mill. After it burned in 1907, its mill pond became a swimming hole for Stratford boys. Its ruins are visible along the trail today.

In 1913 David Lai Len, an immigrant from China, and his wife, Lee Hop Len, moved to Stratford and opened the Snow White Laundry in the Center. Their first child was one of the first Chinese babies born in Connecticut. All five of their children were born and raised in Stratford and were graduates of Stratford High School. The laundry was sold in 1941 when the family moved to New York City.

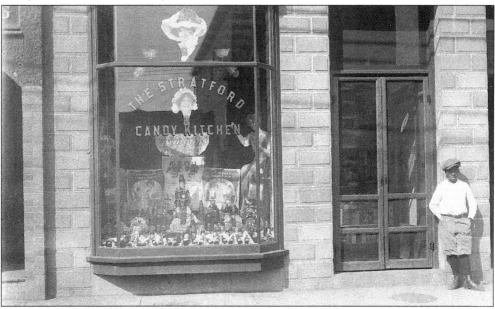

Through the Depression of the 1930s, Peter Kostopoulos' confectionery and soda fountain in the Tuttle Block, the Stratford Candy Kitchen, competed with pharmacies for sweet-toothed customers. Before the Saturday afternoon double feature at the Stratford Theatre, young customers lined up at the penny candy counter.

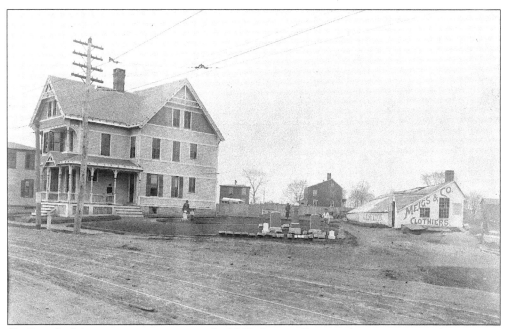

On Stratford Avenue a stonemason at the N.H. Sexton Company's monument works is cutting a new headstone, probably for Saint Michael's Cemetery. Was the Meigs & Co. clothiers ad intended to outfit Sexton's customers?

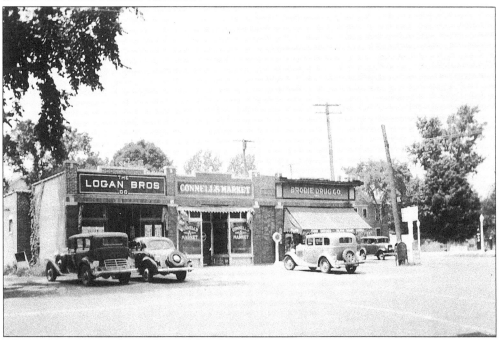

Although 1936 was the middle of the Great Depression, new business centers appeared in town. Hard's Corner, where Post Road traffic streamed by, was one of these. Logan Brothers advertised itself as a grocery chain; there were five of them in town. Edward Connell ran his Grade A Market next door, staffed by his several children. The Brodie Drug Co., under several different owners, became a fixture in the town for many years.

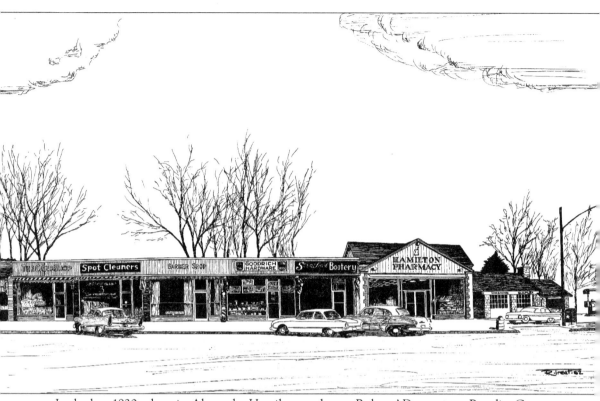

In the late 1920s, druggist Alexander Hamilton took over Roberts' Drugstore at Paradise Green and renamed it Hamilton Pharmacy. In the following years he bought the block of stores and built more. By the time Robert Treat did this line drawing in 1962, the four small stores in the original block—Logan Brothers grocery, Johnson's meat market, Vallancourt's dry goods store, and Hamilton's drugstore and soda fountain—had evolved into the Card Shop, Spot Cleaners, Tony's Nonpareil Barber Shop, and Goodrich Hardware. In the lot south of the stores, Hamilton had added the Bootery, a new much larger pharmacy, and a Gulf gas station.

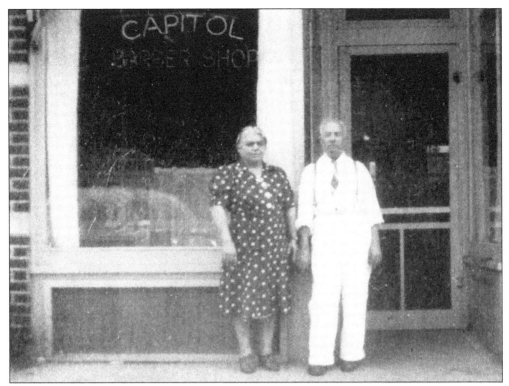

Barbering was a family business in our town. Emile LaReau raised three boys and a girl to become barbers. Emile Jr. still runs a barber shop. Here are Mr. and Mrs. Lorenzo Buchino in front of their shop in Paradise Green. Their children also opened their own shops. Joe Buchino is still in business in the Green.

Vic Musante was a fixture at Paradise Green. He moved his ancient wooden green grocery store from the Wilcoxson Avenue corner to make way for his new brick building, but kept his business going. In 1947, 93-year-old farmer Lobdell could still be seen trundling his produce to the Green in a wheelbarrow. In the 1960s the smell of ongoing vegetable stew would mingle with the odor of Vic's cigar.

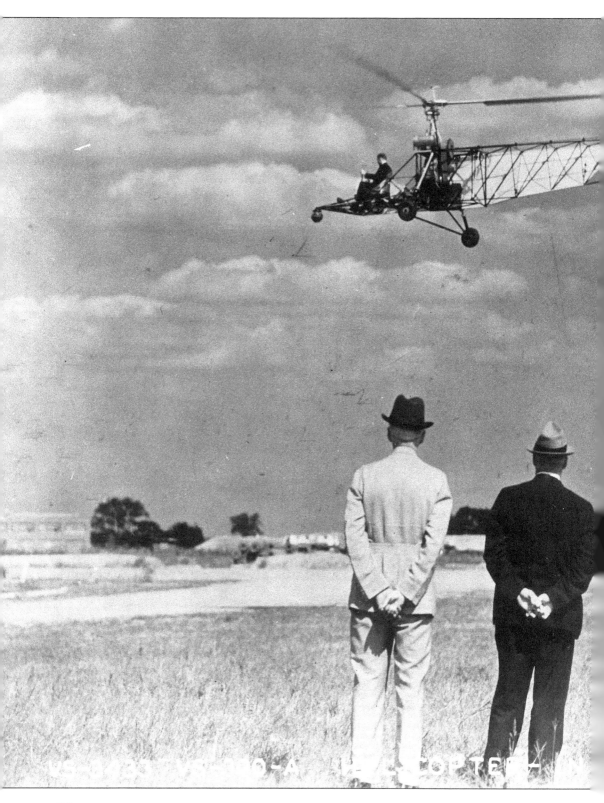

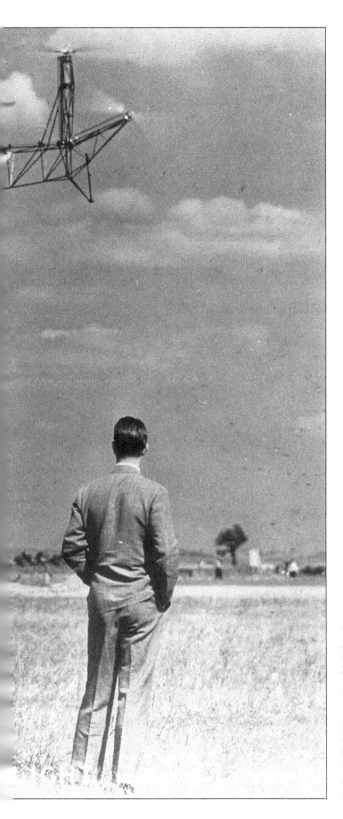

Here are the pragmatist, the pioneer, and the businessman. As pilot Les Morris tests an early version of the VS-300 helicopter in 1941, practical engineer Boris Labensky, inventor Igor Sikorsky, and office manager Serge Gluhareff observe its maneuvers. Mr. Sikorsky once said, "Whatever contribution I have been able to make to aeronautics has been the product of diverse intellects working together in freedom and harmony."

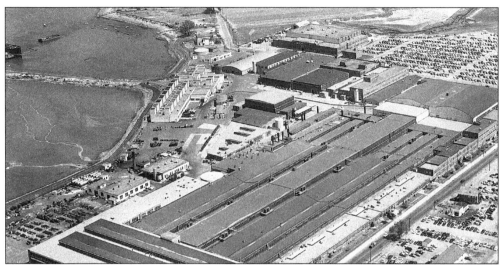

When Chance Vought moved to Texas in 1948, the Stratford aircraft plant became vacant. In 1951 the government, then owner, turned over the factory to the Lycoming Engine Company for the manufacture of helicopter turboshaft engines. The German team of engineers who had created the first production turbojet was brought in to work on the project. The factory, under Avco Lycoming, Textron Lycoming, and Allied Signal, produced more than 10,000 helicopter engines and the engine for the Abrams main battle tank.

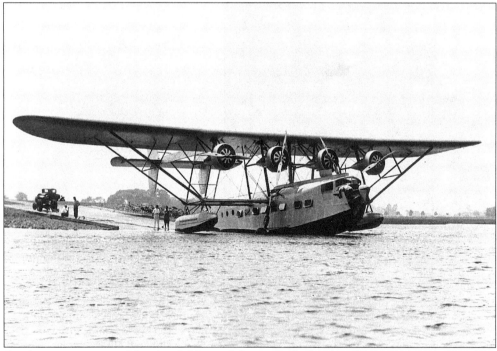

As the ten-passenger Sikorsky S-38 amphibions (sic) developed new airline routes, Pan American asked Sikorsky for a much larger aircraft. The S-40 flying boat was launched in 1931. It was ungainly. Consultant Charles Lindbergh called it "a flying forest." But it held the fort until the much more advanced S-42 clipper was developed. Only three S-40s were ever built, but they logged 10 million miles of flight.

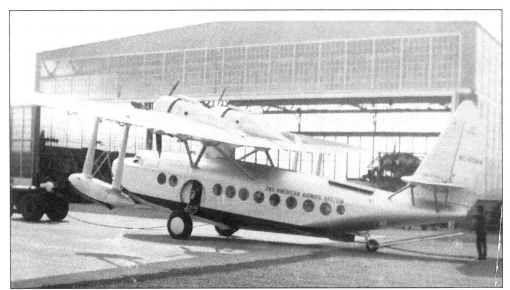

Sikorsky's twin-engine S-43, first flown in June 1935, was a modern 15-passenger replacement for the S-38. Fifty-three of these airplanes were sold.

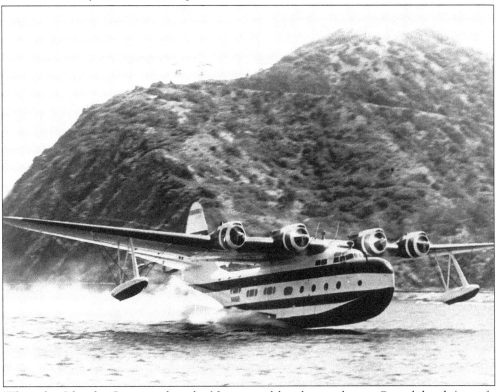

When the Sikorsky Company lost the Navy patrol bomber market to Consolidated Aircraft, the S-44 design became a 44-passenger aircraft capable of 4,500 miles of non-stop travel. Three were built, the Flying Aces *Excalibur*, *Exeter*, and *Excambian*. They provided the only non-stop transatlantic service during World War II, used by VIPs including Mrs. Franklin Roosevelt. The last remaining aircraft, *Excambian*, is on display at the New England Air Museum.

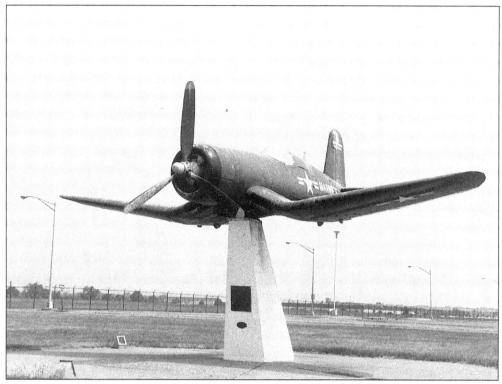

The ultimate propeller-driven Navy fighter aircraft was the Vought F4U Corsair, known to the Japanese as "whistling death." Ultimately, 12,500 were produced by Chance Vought, Goodyear, and Brewster Aircraft, and finally as the AU-1 by Vought in Dallas. Col. Greg "Pappy" Boyington, the Black Sheep Squadron commander and Navy ace, visited the plant and praised the Vought Corsair.

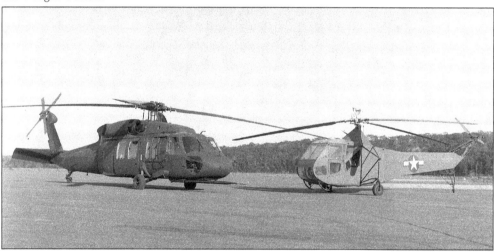

At the Sikorsky heliport in Oronoque, the new and the old meet. The R4 was first flown in January 1942 and in May 1942 it became the world's first production helicopter. Over 100 were built. The modern 3,000-hp H60, first flown in October 1974, is still in production. Thousands have been built for Army, Navy, Marine, Coast Guard, and executive use. They are found in countries around the world.

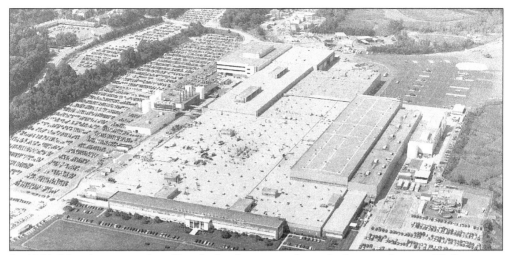

In 1954 Sikorsky returned to Stratford, when ground was broken on January 28 for a new 630,000-square-foot plant on 250 acres in Oronoque. Since then, six new models and thousands of helicopters have been produced here. The Merritt Parkway approach to the Igor Sikorsky Memorial Bridge and a helipad are in the foreground, and Stratford's northern boundary, the Farmill River, is beyond the heliport in the rear.

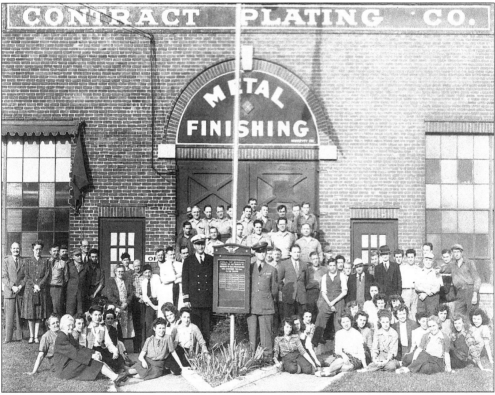

It's September 1944. The Contract Plating Company has been awarded the Army and Navy "E" for excellence in the production of war material, and the entire company has turned out for this photograph with military representatives. For over 70 years many Stratford teens obtained their first work experience with part-time jobs here. The company closed in 1995.

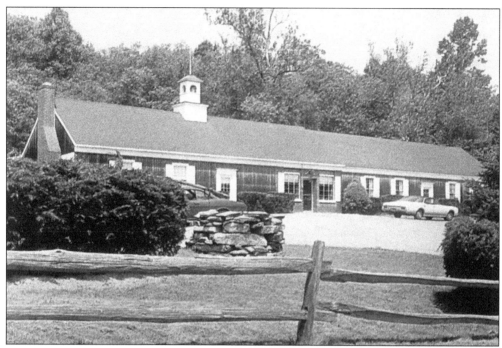

When Betty Winton began baking pies in 1949 to aid her alma mater, her father, banker Elliott Peck, was dubious. But when he saw the crowds at her stand on Sunday mornings, he exclaimed, "Maybe there's something in this after all." Her husband, Hildreth Winton, quit his brokerage job to run the business and Oronoque Orchards was born. Ten thousand pies were sold on each Thanksgiving, and pie crusts were shipped as far as Arabia.

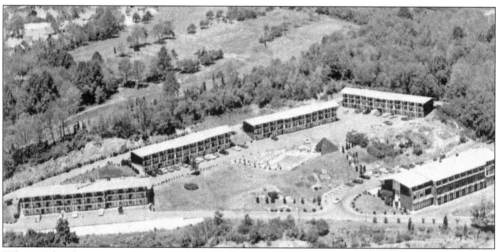

When Sikorsky returned to Stratford and the Shakespeare Theatre opened in 1955, the Stratford Motor Inn and its Mermaid Tavern thrived. Later, when the Connecticut Turnpike opened and new motels appeared, the business shrank. When it finally went bankrupt, its last owner, Senator George McGovern, commented, "If I'd had this experience earlier, I might have understood more during my presidential run."

Three

HORSES, TRAINS, AND CARS

Several 19th-century carriagemakers in Stratford turned out many different styles of carriages. With aid from local tanners, smiths, wheelwrights, and the stump-joint factory, these carriages were shipped by sailing packet to customers up and down the coast. This box-jump seat with shiny brass headlights was considered top of the line at the time.

Frederick Converse Beach and his children, Stanley and Ethel, out for a summer drive, pass his father's house, the Yellow Cottage, on Elm Street in their light Eureka Jump Seat carriage in the 1880s.

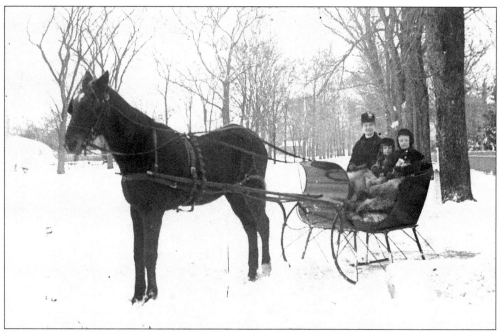

In the winter Beach's carriage was stored in the barn, and his one-horse sleigh took its place. Far from having snow removed by plows, the streets were packed hard by heavy town-owned, horse-drawn snow rollers.

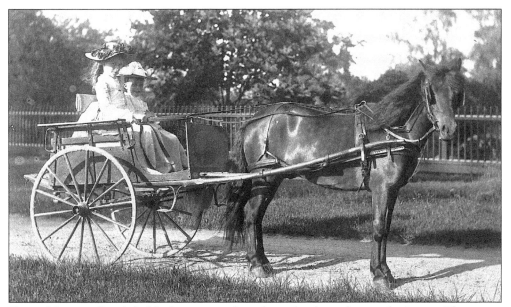

Young Margaret Beach holds the reins with pride as she drives her mother's cart. The gentry went out to be observed, and hired hand Bill Freeman carefully groomed the horse before harnessing him to the rig.

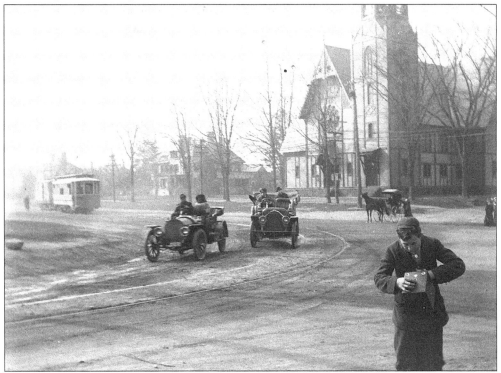

Frederick Beach staged this Stratford Center picture to show a prosperous and busy town. Young Howard Wilcoxson points his own first camera, won in a laundry soap contest, at the cameraman. Two cars and a closed trolley car set the date as c. 1910. Beach's horse-drawn phaeton near the Congregational church completes the scene.

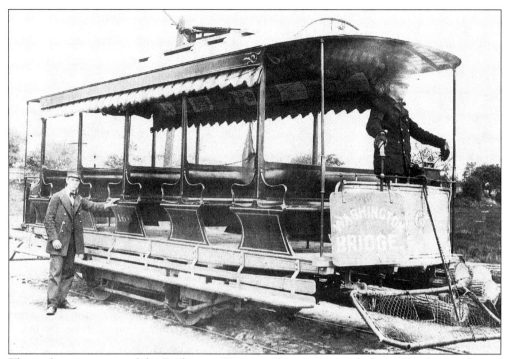

The earliest streetcars of the Bridgeport Traction Company seated about 45 riders, and more could stand on the running boards. After accidents with pedestrians, a retractable "cowcatcher" was added. The open two-man cars had a side curtain that could be lowered in rainy weather.

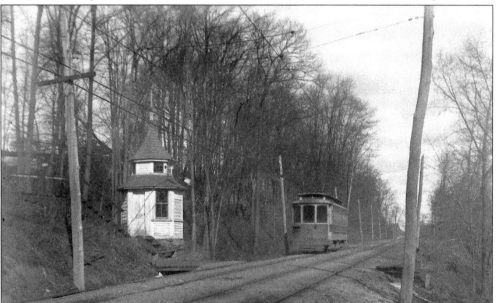

The car from Derby to Bridgeport approaches Boothe Station on the Connecticut Railway and Lighting Company line *c.* 1905. Built in 1899, the line along the river offered regular service on a picturesque route when horse-drawn carriages on dirt roads were the only alternative. The Boothe family in Putney built their own waiting room at the river. It can still be seen at Boothe Memorial Park.

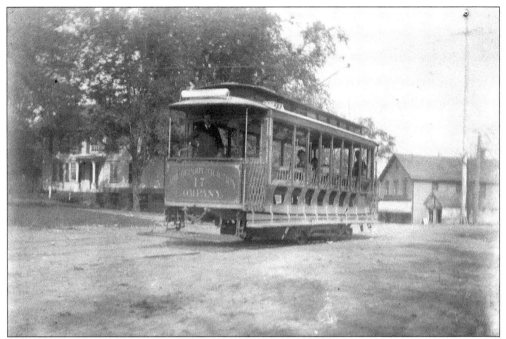

Bridgeport Traction Company Car #17 heads toward Stratford Avenue and downtown Bridgeport from Stratford Center *c.* 1900. This trolley had a single four-wheel truck, cross seats with side entry, and a running board for the conductor to move along collecting fares.

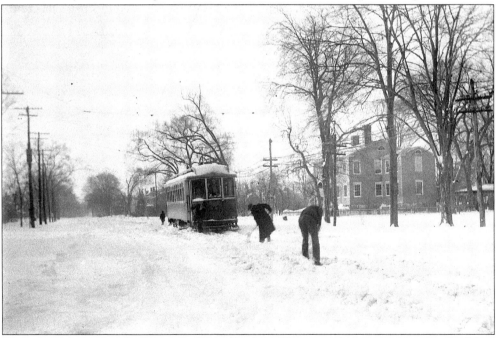

Winter weather was a challenge for the trolley line. Here men dig out as a car waits on Main Street at West Broad. Work cars with plows or large rotating brushes cleared the line of snow, but more importantly, flangers scraped ice from the rails to prevent derailing. Winter travel on the trolley car was a pleasure; electric heaters kept the passengers warm and comfortable.

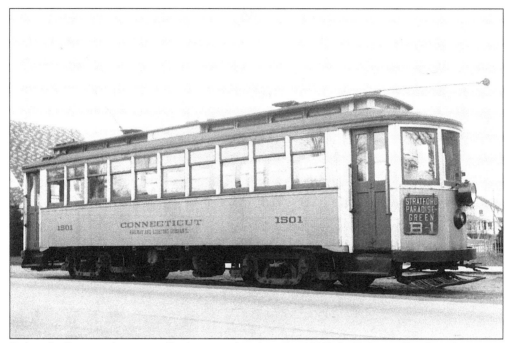

Before the Barnum Avenue trolley line was abandoned in 1935, the B-1 car offered an alternative to the Stratford Avenue route from Bridgeport to Paradise Green. When shifts changed, these special "trippers" sped the workmen home from the Singer and Remington factories on Barnum Avenue. The Barnum Avenue hill made the older 1500-series wooden cars preferable to the newer, larger, but less powerful, steel cars.

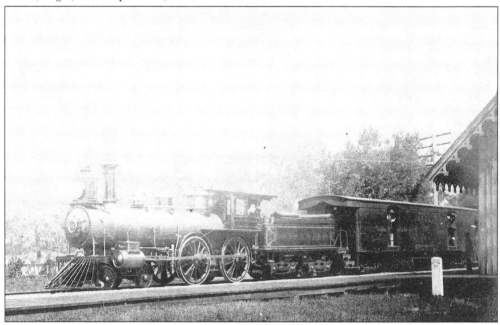

At the old Stratford Depot of the New York, New Haven & Hartford Railroad (the Consolidated Road), Engine #116 and the 8:41 accommodation wait patiently while the baggage master loads wild ducks and iced oysters for New York in the 1880s.

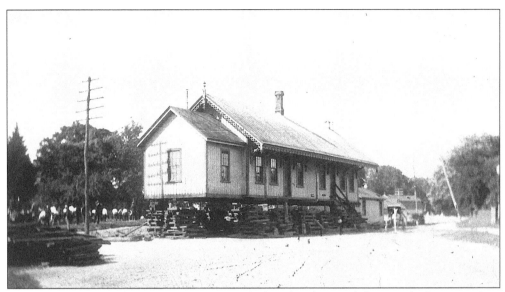

In 1894 the New York, New Haven & Hartford Railroad moved the Stratford Station from Linden Avenue to its present location east of Main Street and elevated the tracks. This was the second station building, erected sometime before 1882. Today this building is located at the eastbound platform, and a new building is at the westbound. Neither building is used as a station; one is a museum and the other is a restaurant.

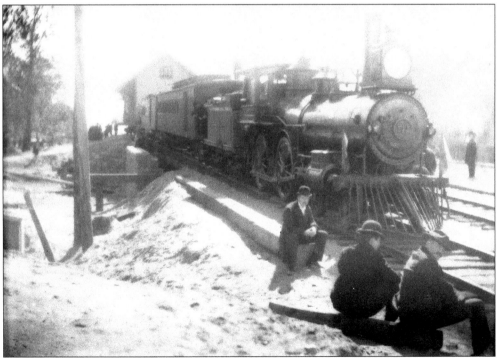

Locomotive #117, a 4-4-0 American-class passenger engine, moves the station 600 feet down the line and across the new Main Street viaduct to its new location. The original station building at Railroad (Linden) Avenue, built in 1849, was probably also moved to become a new freight station.

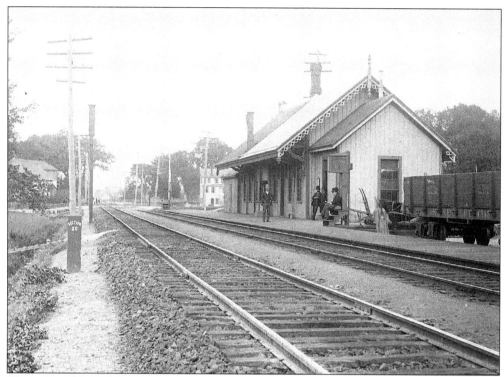

This scene shows the railroad in 1893, just before it relocated the depot and became four-tracked and elevated. The King Street and Main Street crossing gates are visible.

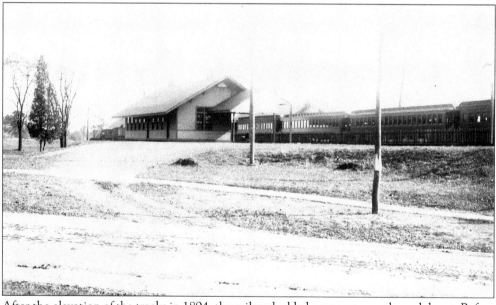

After the elevation of the tracks in 1894, the railroad added a separate westbound depot. Before the electrification of the line in 1914, the depot looked like this from across Main Street. Today a seafood restaurant, Shell Station, occupies the building, and tickets are bought on the Metro North train. Metro North runs commuter cars into New York, and long-range Amtrak passenger trains speed from Washington, D.C., to Boston.

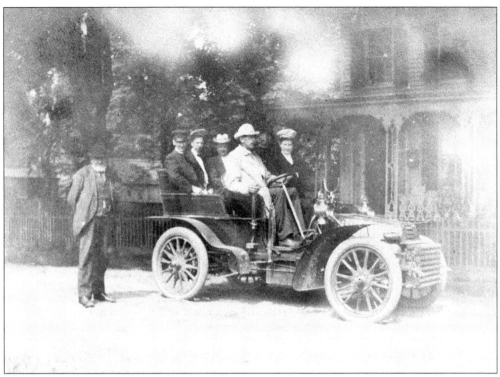

A group of early motorists goes for a drive in a $2,500, 1904 chain-drive Searchmont, an extremely rare car even then. The party is posing at the home of Alfred Curtis on Linden Avenue (later Shakespeare Arms).

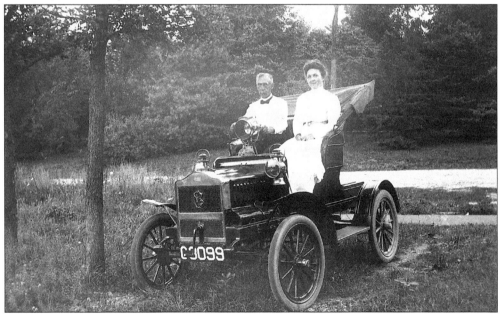

Among the earliest cars in town was this 14-hp 1908 Maxwell, with engineer Ernest B. Crocker at the wheel. E.B. Crocker was a leading member of the Housatonic Boat Club, and served as its commodore for 11 years. The car cost him $825.

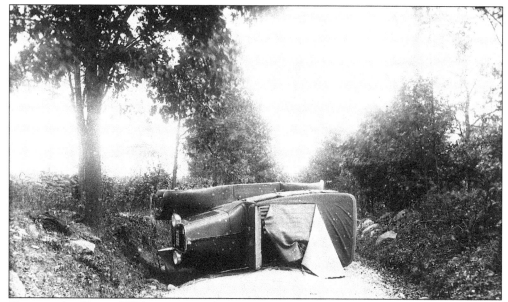

Photographer Howard Wilcoxson, wandering the back roads near Stratford in his own 1929 car, stumbled across this overturned vehicle on a country road.

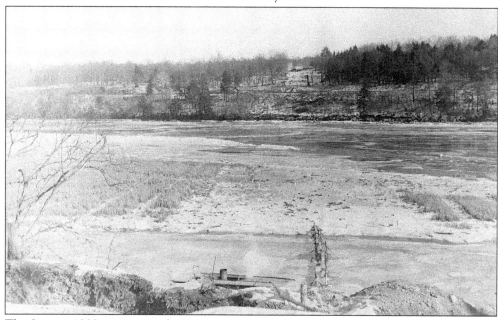

This January 1939 view across the Housatonic River toward Milford shows what would become the Igor I. Sikorsky Memorial Bridge. The Merritt Parkway was originally intended to end in Stratford, and right-of-way was bought to Barnum Avenue and toward Washington Bridge. When plans were changed in 1937–38, local Republicans bought up land along the route and the scandal tainted Democratic Governor Wilbur Cross. Stratford Republican Raymond Baldwin, who had been offered land but turned it down, beat Cross in the 1938 gubernatorial election, and the bridge opened on September 2, 1940. "Uncle Toby" Cross lost as governor, but they named the rest of the parkway, to the east, for him. A tollgate from the Merritt Parkway Bridge can be seen at Boothe Park.

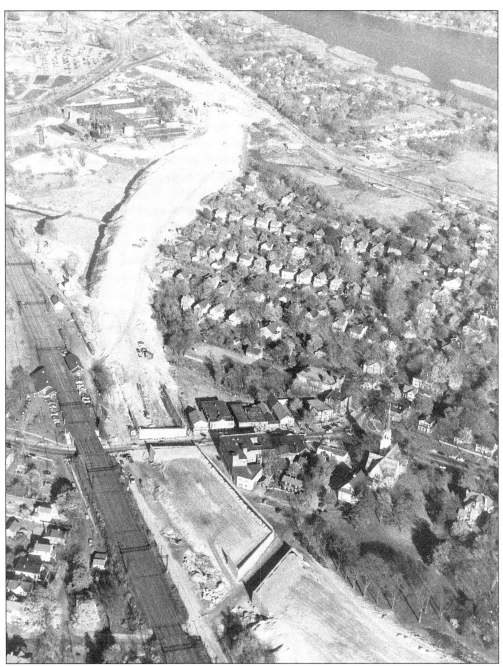

Locating the route for the new interstate highway in the 1950s was difficult. The towns were all built up, with expensive real estate everywhere. As this aerial view shows, I-95 wiped out half of Sterling Park and much of Stratford Center, did an S-curve to miss Raybestos, and crossed the river south of the railroad bridge. Governor Lodge opened the Connecticut Turnpike on January 2, 1958, and the road was later named for him. The bridge was named the Moses Wheeler Bridge in honor of our first ferryman, who had toiled there in 1650.

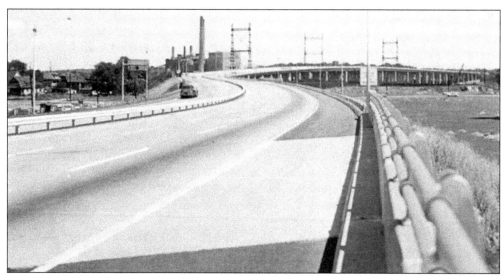

The Connecticut Turnpike in 1958 was just that, a road with several tollgates where cars paid a quarter to pass. Huge trucks took over the turnpike as rail freight declined, and several fatal accidents occurred at the Stratford toll station. One truck smashed into a station wagon, killing seven passengers. Another, appropriately labeled "New Jersey Compactor Company," crushed a passenger car into a truck ahead of it because of failed brakes. In 1986 the last tollgates were removed.

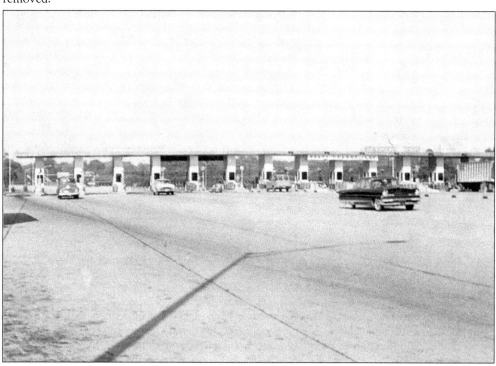

Four

HOMES THROUGH THE YEARS

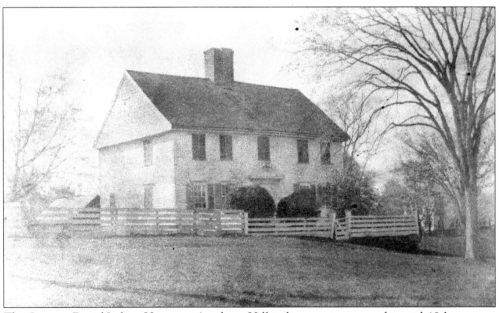

The Captain David Judson House on Academy Hill is shown as it appeared in mid-19th century. Built before the Revolution, the house stood on the site of William Judson's 1639 homestead. Only the pediment above the front door and the bullseye glass lights within the door relieved the stark and simple architecture. The two boxwood plants at the front entrance were 6 feet high.

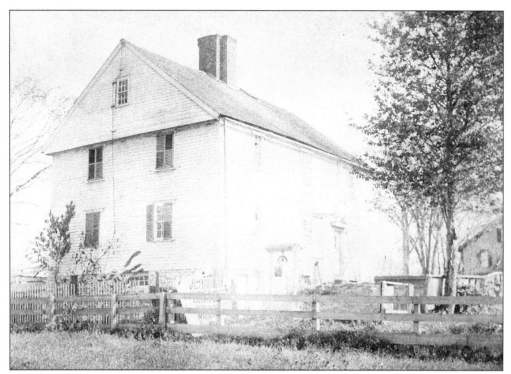

For its first 100 years, the Judson House's color changed from red to yellow to white, but little else was altered. Outside shutters cover the windows in place of indoor wooden Venetian blinds. An open well stood near the cellar door and a plain-board fence enclosed the property.

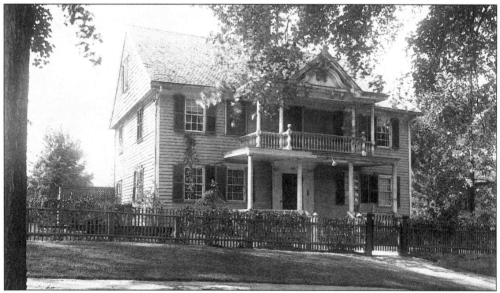

Merchant John V. Wheeler brought the Judson House up to Victorian standards in 1888 when he added an ell in the rear and built a grand two-story porch in front, moving the entry pediment up to the eaves. All this was done to persuade his neighbor, widow Susan Elizabeth Johnson Hudson, to become his bride. All came to naught when she advised him, "We don't marry into the trades."

Frank Sammis studied house plans carefully before deciding what to build. In 1887 he designed and built this Shingle-style house on Academy Hill, complete with third-floor ballroom. It is gone now, and its houselot is the scene of historical society festivals.

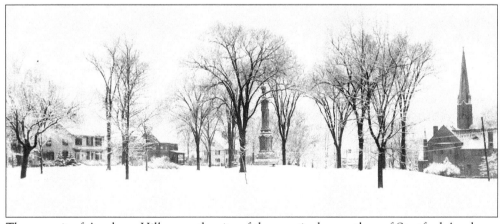

The summit of Academy Hill, once the site of the meetinghouse, then of Stratford Academy, welcomed the tall monument to servicemen of the Civil War in 1889. Since then the townspeople have paid tribute to all our veterans at this spot each Memorial Day.

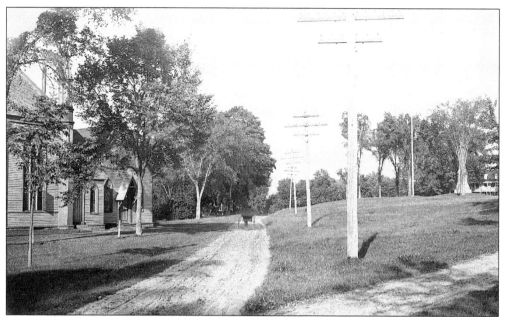

In the 1800s a highway ran from Main Street diagonally across the base of Academy Hill to Broad Street. From the academy, students looked down on passing wagons, carts, stages, and circuses heading to New Haven or Bridgeport. The road to the right across the hill was added in 1892. Today the old diagonal road is gone, its grade barely visible in some spots, in others covered by the Christ Episcopal Church parish hall.

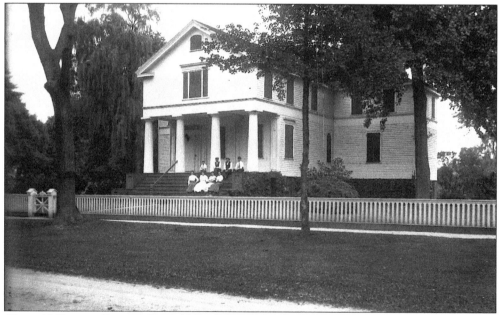

About 1840 aging Captain Samuel Nicoll decided to leave Lordship and move uptown to Elm Street. After the deaths of the captain and his wife, Elvira, the house was owned by her nephew, John Benjamin, a founder of the New York Stock Exchange. From 1887 to his death in 1906, he spent his weekends presiding over the Housatonic Club on the river behind the house. Here Benjamin family members pose outside the house.

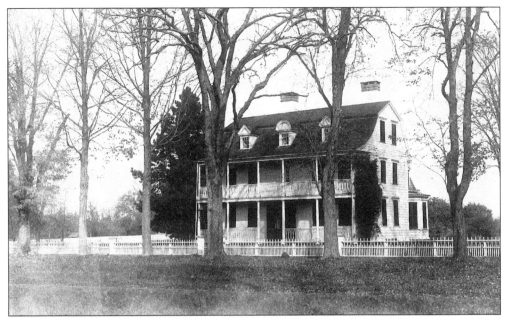

When Captain Samuel Southworth married Abigail Wells in 1752, her father gave them land to build this home, a duplicate to William Beach's house on lower Elm Street. It passed to shipbuilder Daniel Curtis, then to Captain Joseph Prince, then to Congregational minister Stephen Stebbins, then through the Otis, Poore, and Dewitt families. Early in the 19th century the magnificent porch galleries and the ell in the rear were added.

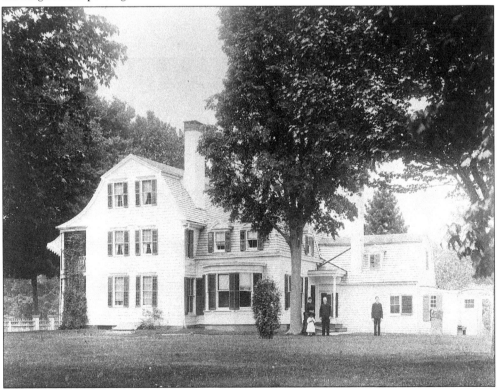

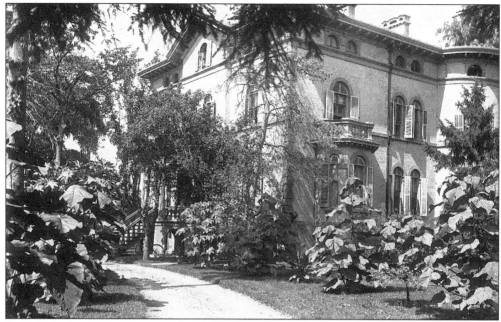

In 1864 Frederick Benjamin tore down the old Benjamin's Tavern on West Broad Street where Washington and Lafayette had met, cleared half the block, hired New York architect Frederick Schmidt, and built this Italianate brownstone mansion, larger than any other in town. Here his son, A. Bedell Benjamin, and his son's wife, Jessie, lived in leisure when not cruising in their five-man steam yacht. One of Stratford's many rooming houses during World War II, the house is still rented out to roomers.

Waiting for their groom to ready the horse, Bedell and Jessie Benjamin relax by their carriage house. An avid photographer, Bedell may be planning to record some new scene in town.

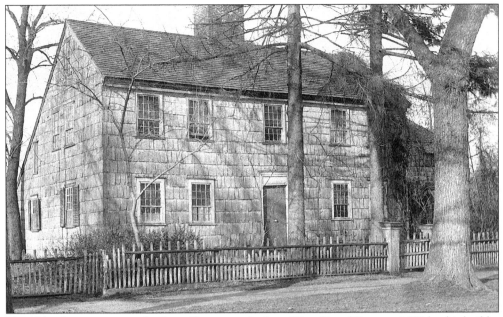

The oldest house in town, the Perry House, was built on West Broad Street c. 1680 by shipbuilder Benjamin Beach (if we believe the original roof slope indicated by the rafters and the partial cellar). A new roofline has been added and the old shingles have been removed since this 1880s photograph was taken.

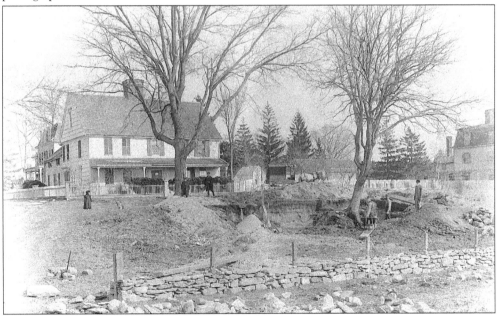

The ancient Nicholas Knell House at Sandy Hollow was long thought to be built in 1680 with timbers from the first meetinghouse. In 1969, evidence showed that it was probably constructed in the mid-18th century. In 1891, James Meachen bought the barn lot where the first meetinghouse had stood. He dug this cellar hole for the two-family house that would rise here. Occasionally, digging on this property has uncovered the remains of 17th-century settlers buried in this earliest graveyard in unmarked graves.

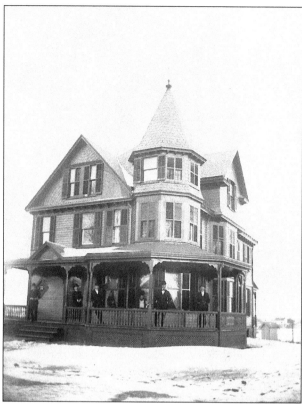

Dan C. Wood's Queen Anne-style home on Main Street was just a few minutes walk from his sawmill on Longbrook Avenue. He sold the house to Alexander Trumbull, maker of the Trumbull Cycle Car in Bridgeport. Trumbull went out of business when a U-boat sank the *Lusitania* with a load of Trumbull cars in her hold.

This 19th-century view of the side yard of the Judge Peck place on Main Street gives us a good feeling for the area around many of the homes, both large and small, in Stratford. The Judge's daughter, Mrs. Dan C. Wood, lived to the left in the house pictured above. In the 1930s, Barnum Avenue Cutoff was built between them. Both houses were torn down in the late 1950s.

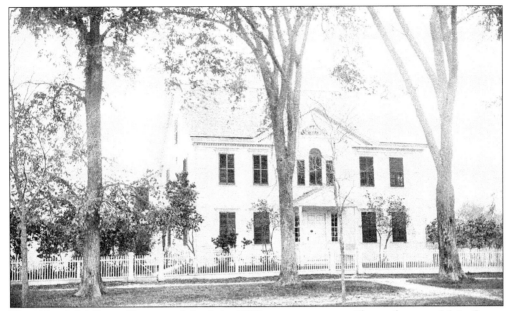

The Abijah McEwen Homestead, built in 1790, presents a magnificent front on Main Street between the library and the Sterling House Community Center. It features a well-preserved doorway, central window, and a fan light that accents the peak of the house.

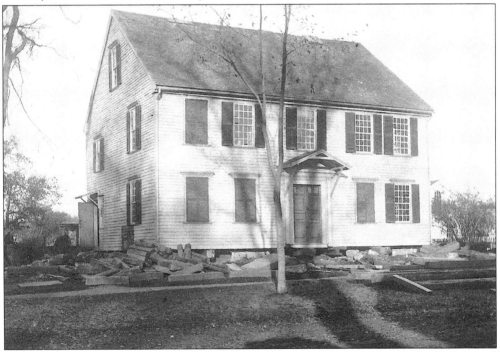

Dr. William Agur Tomlinson built this house on Main Street in 1772, just before he went off to fight the British. Later, Yale Hebrew Professor Roswell Judson lived here, followed by Judge Robert Russell. With the construction of the library, Judge Russell had the house moved a block east to Elm Street in 1895. Miss Fannie Russell, the head librarian for 52 years, reminded patrons that her office stood exactly where her bedroom had once been.

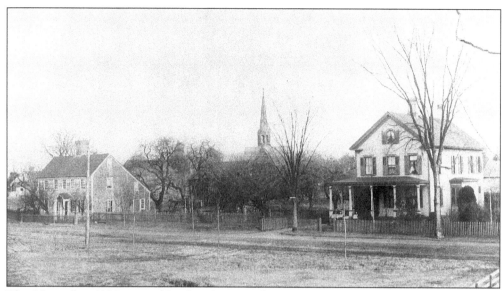

This November 1898 view of Linden Avenue, then part of Lundy's Lane, shows young trees planted where the railroad depot had been. Hamilton Burton's saltbox, where his father had operated his weaving business, is across the road. A new Victorian house, owned by Judge of Probate Charles H. Peck (who photographed this scene), has been built alongside. In the distance, the steeple of the Congregational church tells us where the Center is located.

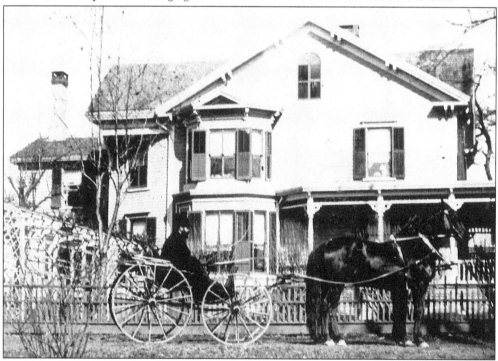

David P. Rhoades, a successful New York City merchant, owned this house on King Street at the end of the 19th century. Here he proudly shows both home and transportation on a winter's day. The concrete stone used by Mrs. Rhoades to step up into the carriage is still on King Street near the corner of Broadbridge Avenue, complete with its original "R."

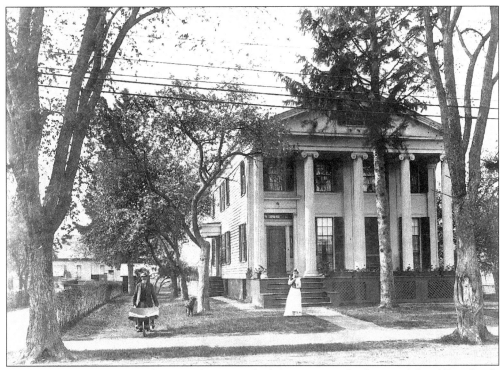

This impressive 1840s Greek Revival on Stratford Avenue was the home of the Allen family when this photograph was taken. During the World War I influenza epidemic, the Red Cross maintained an infirmary here. The house was demolished after 1945 when the Keating Ford property expanded westward.

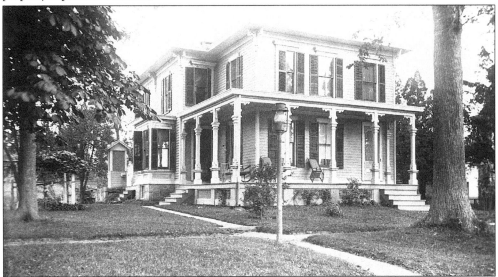

Homes of almost every architectural style were built in Stratford. This flat-roofed Victorian on South Main Street shows many features of its time including the long porch with its high-backed rockers tilted against the weather, window shutters (which actually worked to close out winter winds and summer sun), and the covered well in the rear. The oil street lamp lit the way at night.

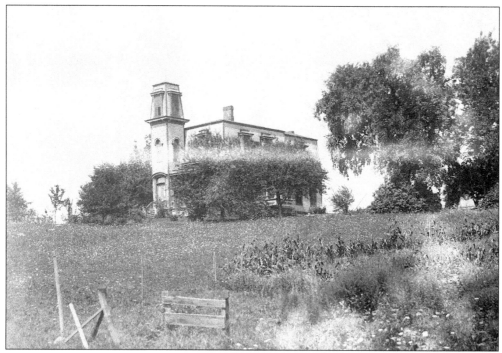

At the top of Booth Street Hill, once Clapboard Hill, the Graham House was built between the distillery and the slaughterhouse to look out over Long Island Sound. In the 1930s a German immigrant named Miller moved in and opened a butcher shop down the hill on Barnum Avenue. For many years Miller made wursts and cold cuts and, best of all, Braunschweiger liverwurst, packed in animal casings.

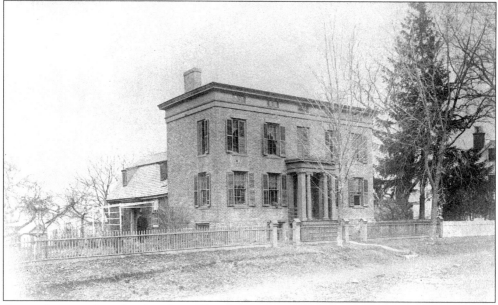

Across the street from the church on Church Street stood Doctor Goulding's mid-19th-century home. Through the orchard the stores on Main Street in the Center are visible. To the right is old Bennett's Tavern, later Dr. Hennessey's then Dr. Friedman's office.

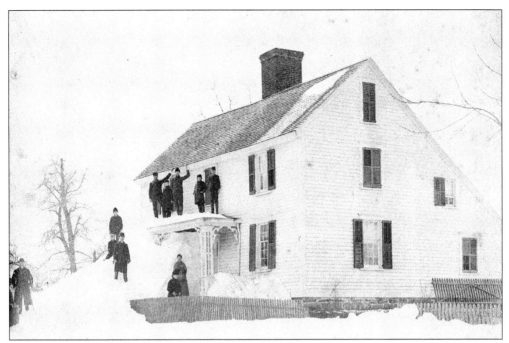

On March 12, 1888, a surprise snowstorm dumped two days of heavy snow on New York and New England. The entire Northeast was paralyzed. Trains were stalled, coal ran out, and business in Stratford ceased. As teams of men dug out, it was a photographer's paradise. Frederick Beach and Bedell Benjamin wandered the town for pictures. This scene at Lewis Beardsley's house on Linden Avenue shows the effect of drifting snow.

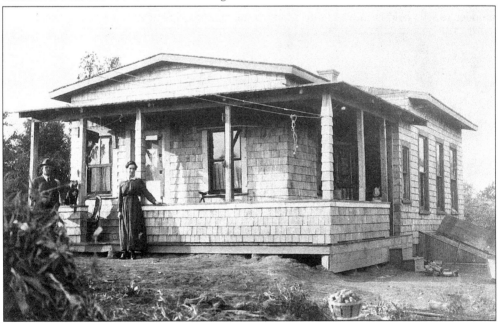

The small house of Mr. and Mrs. James Stewart "was built from lumber from the Dayton House" in Stratford Center. It was torn down in 1916 when the Stratford Trust Bank building was erected on the property.

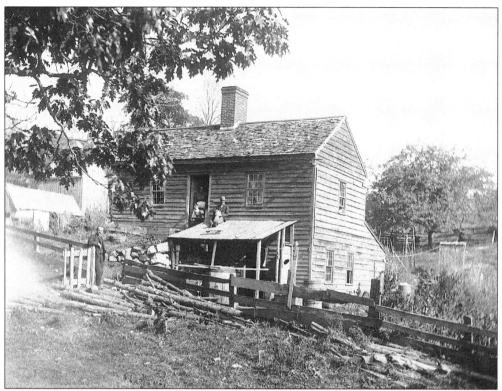

Before the coming of urban sprawl, the northern hillsides were dotted with subsistence farms. An orchard, a couple of cows and pigs, a pasture, a field to plow for family vegetables, and some produce to sell could sustain a family. Many of the families were newcomers to America.

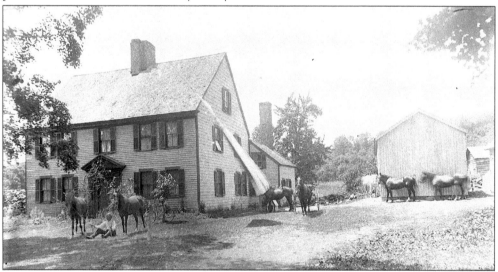

The Wooster Farm is a good example of a farm owned by a prosperous family for many generations. Built by Col. Joseph Wooster in 1750, it stood on the north side of the Farmill River. It burned to the ground in 1914. Gen. David Wooster, who fought in battles at Louisburg and Fort Ticonderoga and who died at the Battle of Ridgefield, spent his first nine years on this family farm, before this house was built.

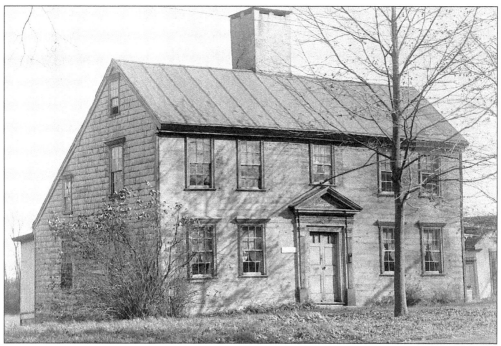

It was about 1735 when Nathaniel Curtis built this home on lower Front Street (Elm Street). Its land ran to the river. Nathaniel's daughter Lydia married Thomas Hall in 1734 and moved to Wallingford. Her great-great-great-grandson, Winston Churchill, was prime minister of Great Britain. The house changed hands, and when it was bought by Alfred Ely Beach, it was being used as a duck farm.

When the old Nathaniel Curtis House was threatened with destruction to make way for a large brick condominium, Ned Richardson and his wife, Margaret, a Curtis descendant, attempted to save it. Working with contractor Jack Wardman, they were able to move it up the river in 1973 to Housatonic Avenue, where it stands restored today.

Many variations of these English Tudor Cottage-style houses were built in Stratford in the 1920s, particularly in Paradise Green. This amount of decorative detailing is rarely seen in houses built after World War II.

Five

ON THE RIVER

In the late 20th century, pleasure boats began to dominate the river. Except for oil barges headed to the electrical plant, commercial shipping is gone. Oystermen's boats and the buy boat are reappearing, but power yachts and sailing yachts have filled the yacht clubs and marinas.

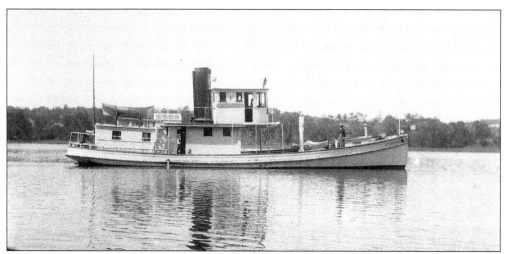

A. Bedell Benjamin, the richest man in town, was a frustrated sea captain. For many years he cruised the sound with this converted oyster steamer, named *Lizzie H.* after his mother. He held a commercial masters license, was prominent in the New York Yacht Club, and owned the finest collection of steamboat lantern slides extant.

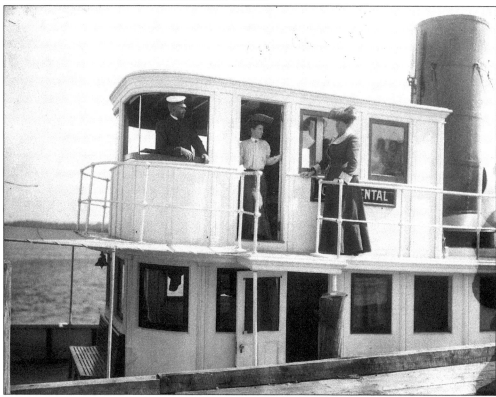

Bedell Benjamin's last steam yacht was the 84-foot *Continental*. Guests invited for a cruise had to be prompt. If they weren't on the boat at the moment of departure—even if they were descending the catwalk to board—they would hear a whistle blast, and a "cast off!" call, and be left standing at the dock. The captain is leaning out the wheelhouse window and wife, Jessie, stands in front of the name board.

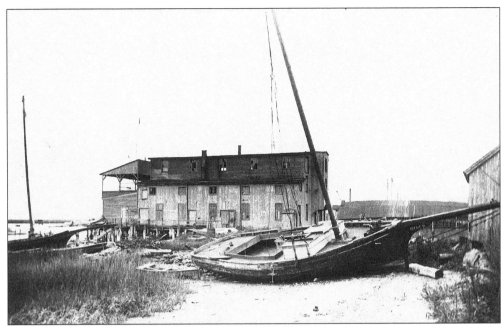

In 1903 the Lewis Oyster Company moved to Bridgeport and left its oyster house to the Pootatuck Yacht Club. The club dressed up the building and added porches and mooring spots in the anchorage. For years the club lay surrounded by derelict boats. Finally, in 1927, contractor Sterling Filmer built a brand new two-story clubhouse on pilings, surrounded by verandas. The old oyster house was then condemned.

Looking up the Beach's private road in the late 1890s we see that John Beach's studio has already been removed to the Housatonic Boat Club, but the "Katherine Hepburn" cottage (so-called) sits on pilings. A boat rests at the high tide line and the oyster sloop *Sheldrake* lies in the inter-tidal zone. A carriage path outlines the road above the bank.

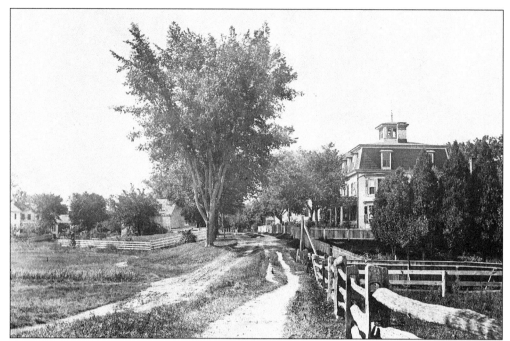

This view looks west *c.* 1890 toward Mack's Harbor, where the town began. From 1639 through the 18th century the marsh was an open harbor. The barn (to the left of the tree) marks the site of the first meetinghouse, which was surrounded by the town's first cemetery. The French Provincial house on the right has a saltbox frame built in 1742. It sits on the house lot granted to the town's first innkeeper in 1650.

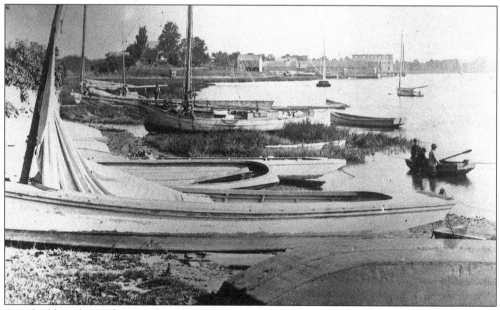

Stratford has always depended on the river. The sharpies drawn up on the bank above the lower wharf in this 1880s photograph were used by oyster tongers. The coasting sloops beyond are moored in the stream, and in the distance Peter White's shipyard (later Bedell's, now Brewer's) is visible.

By 1800, New Lane bridged Ferry Creek and led to Daniel Curtis' shipyard, the ropewalk, and the upper wharf. The yard, on Curtis Point, had been busy building ships for centuries, including sloops, two-masted schooners, and steam oyster boats. Today the road is Broad Street and the yard is Brewer's Stratford Marina.

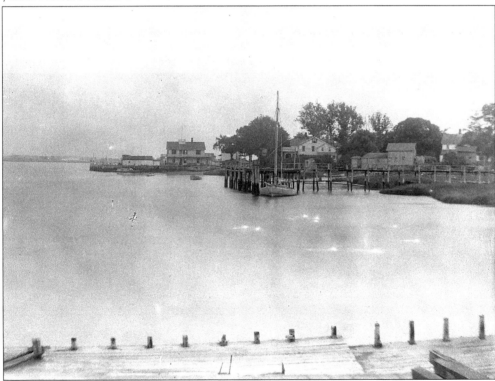

This 1885 view downriver from the upper wharf at New Lane shows the lower wharf ready for steamboat traffic. Bought by Capt. John Bond, the warehouse on the wharf became a prizefighters' training quarters and saloon. His brother Ashabel built oyster boats in the shed on the wharf. Other businesses included oyster sheds, a tannery, a weaver's shop, a sailmaker, and a ship's chandlery. The sloop in the foreground is tied to Bedell Benjamin's private wharf.

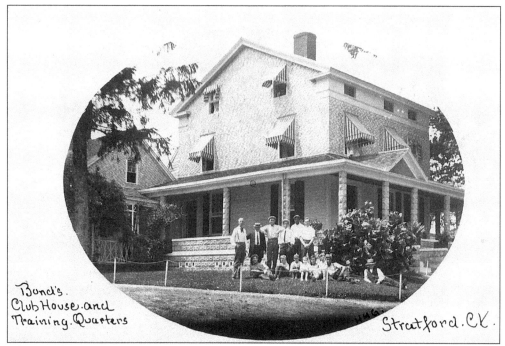

Bond's.
Club House and
Training. Quarters

Stratford. CX.

John Bond's home and rooming house, actually two houses drawn together, stood across the road from the saloon on the dock. The fighters/boarders are gathered here with admiring neighborhood children. This house came down in 1942 after the town took over the property.

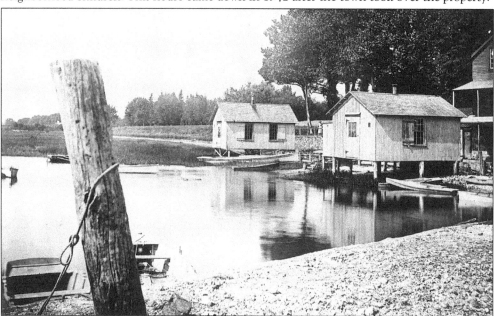

From Bond's Dock southward, oyster stores filled the shore then spread out on pilings. This early 1880s picture shows James Meachen's oyster stores at the right, two more in the large building, and one at the end of Meachen's dock. John Beach's studio is in the center. In 1893 this building was moved downriver to become the men's bathhouse at the boat club. Meachen's shed went out to sea in the 1955 hurricane.

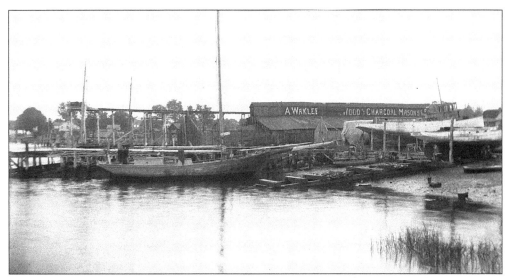

A phosphate factory and coal sheds were located at the upper wharf on Broad Street. Cargo brought in by schooners and steamboats was gradually directed to the warehouse of Alfred Waklee. Coal, coal oil, lumber, masonry, manufactured goods, and groceries arrived. Some Center merchants moved their goods immediately to their own stores, but most were stored in the warehouse. By 1913 Waklee replaced this building with a new one.

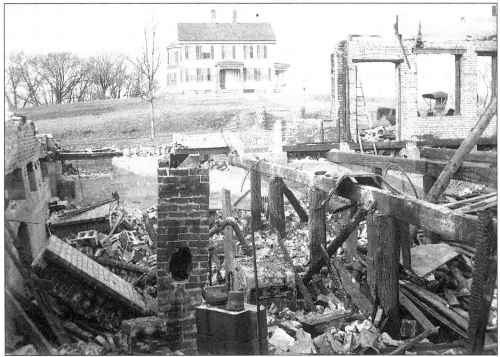

Waklee's new warehouse was built on Ferry Creek as a brick-and-concrete block three-story building. Waklee had just moved into a second-floor apartment when, on March 8, 1914, the building was destroyed by fire. Waklee rescued his wife and her grandmother with a rope of blankets, but hired worker Frank Monohan died. The warehouse was rebuilt and occupied by Huntington Aircraft, Bedell's Shipyard, and a business school in turn. It was removed in 1998.

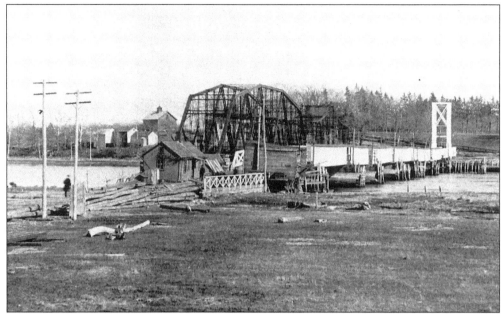

From 1803 to 1894, a rickety wooden bridge provided river crossing. In the spring of 1807 ice carried the bridge out to sea. Vessels passing through the draw often collided with the structure. In 1868 the draw collapsed on the steamer *Monitor*, and the bridge was out of service for a few years. It was with pleasure that Fairfield and New Haven Counties opened the new iron bridge in March 1894.

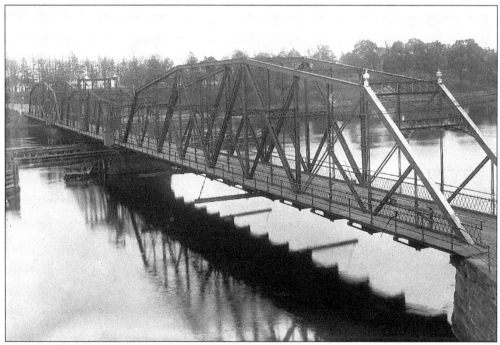

The new $88,500 bridge had a 200-foot swing span and two 215-foot fixed spans, but it was only 17 feet wide. Its stone piers reached down 28 feet below sea level. The railroad, a powerful force in the legislature, insisted that it not be wide enough for a trolley line to forestall competition.

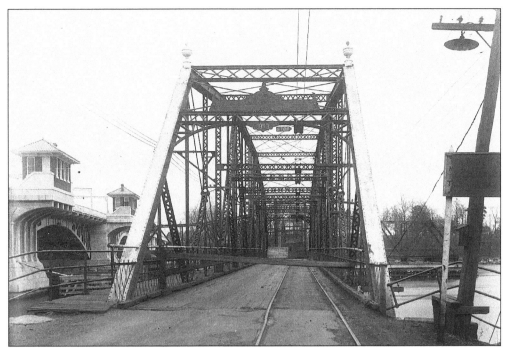

In spite of the New York, New Haven & Hartford Railroad's remonstrances, a single-track trolley line did succeed in crossing the Housatonic on Washington Bridge, but it disrupted growing automobile traffic. By 1917 the railroad had bought the trolley line and agreed to a new wider bridge. The war intervened, but on Armistice Day of 1921 a new modern bridge opened, the present Washington Bridge.

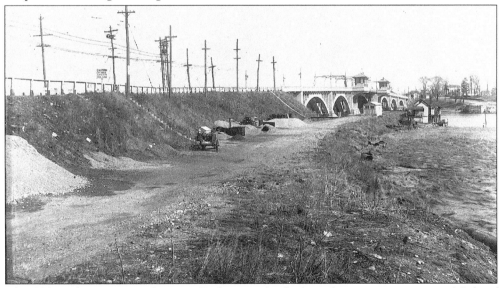

The fifth and present Washington Bridge was (and is) modern in every respect. Made of reinforced concrete, it stretches 967 feet, with a 175-foot, double-leaf steel bascule lift span. Clearance over high water is 32 feet. The highway is 43 feet wide and there are two 8-foot sidewalks. This view toward Milford shows the abandoned approach and the little seafood stand that stood on it.

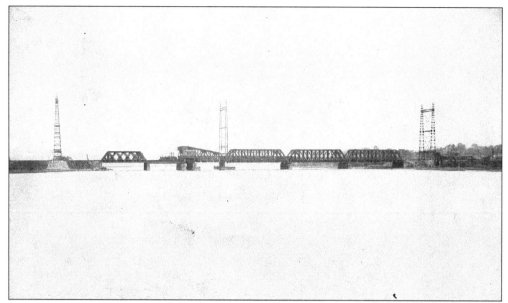

The first railroad bridge across the Housatonic was a single-track 1,293-foot wooden covered bridge. It was replaced by a double-track, cast-iron bridge, then by a two-track steel structure. In Charles Mellon's massive program to modernize the railroad after 1905, the bridge became the present four-track steel bascule bridge shown here. The improvement program bankrupted the railroad, but that bridge is still in use.

Until the Ousatonic (sic) Dam was built between Shelton and Derby, shad filled the river every spring as they returned to their spawning grounds. Fishing spots were leased out to groups of men, who built weirs or spread gill nets in their assigned places. The fish were gutted, salted, dried, and packed into barrels for shipment all over the country.

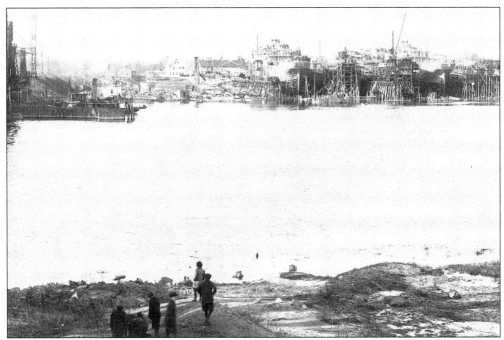

In World War I the National Shipping Board set up 160 new shipyards to fill the need for tonnage. The Housatonic Shipbuilding Company set up six sets of launching rails north of the railroad. Keels were laid for six wooden steamers. Because of the war's end, however, only the *Fairfield*, launched on December 31, 1918, was completed. Engines were never installed in the other five; they were used as 267-foot barges on the Hudson River.

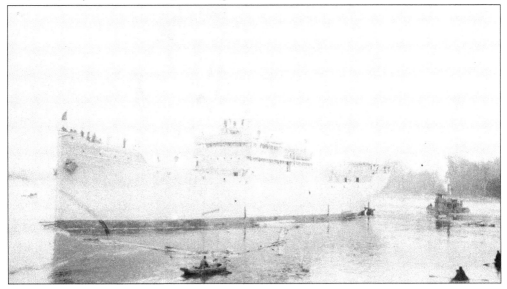

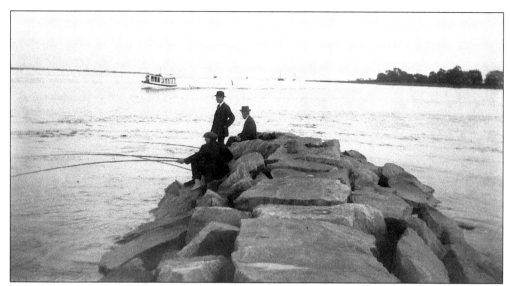

The construction of breakwaters in the Housatonic River began in 1890 and was completed in 1911. For years the tug *Evona* towed the old sloop *Commodore Jones* down from Derby loaded with stone. This section, completed last, extends from Stratford Rock (now the Birdseye Street launching ramp) to turn the flow of ebbing tides. It now sports a green navigation light and is still a place for fishermen. We call it "the jetty."

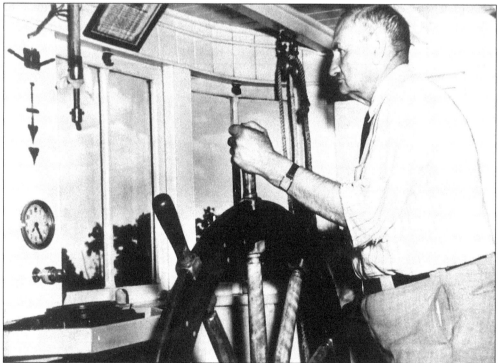

Charles E. "Shang" Wheeler became an oysterman when very young and worked at it all his life. While a state legislator he presented important environmental preservation legislation, but he is best known for his decoy carvings, the ultimate in the art. Here, as manager of the Milford Oyster Company, he is heading out to supervise work on one of the leased oyster beds.

Six

LORDSHIP AND THE SOUND

When the town acquired Short Beach in 1925, most of it was leased to cottagers; only a short stretch was available for public use. In the 1960s the last cottage was removed. Now 107 acres and 3,335 feet of shoreline are dedicated to swimming, picnicking, and recreation.

Road to Stratford Point

When a new lightkeeper's cottage was built in 1881, the old keeper's house was moved away to the Merwin Farm. The last farmer to raise crops here near Half Moon Cove was William Irving "Ike" Lobdell. The land lay fallow from 1906 until Army barracks were built on it during World War II.

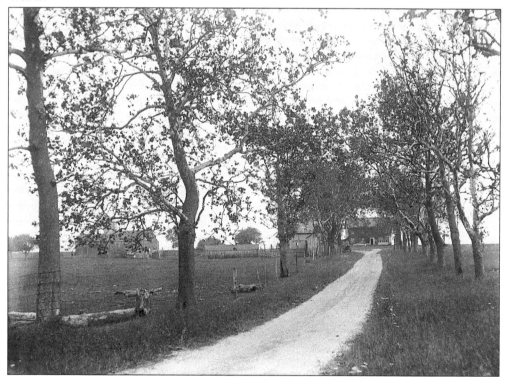

In 1818 Capt. Samuel Nicoll built this manor house on his 150-acre farm at the west end of Great Neck. Privateering in the War of 1812 netted him 1.5 million dollars in spoils. The house is still there, at 139 Fourth Avenue.

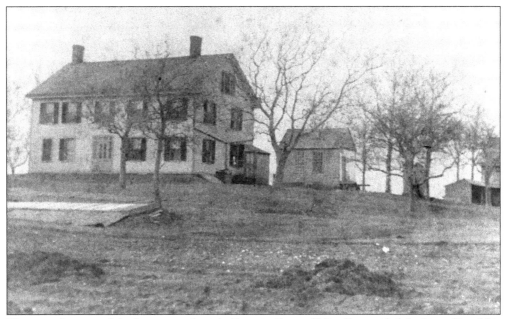

This is a close-up of the house nearly rich Captain Samuel Nicoll provided for himself and his bride, Elvira. The farm was called Lordship Manor from an ancient deed.

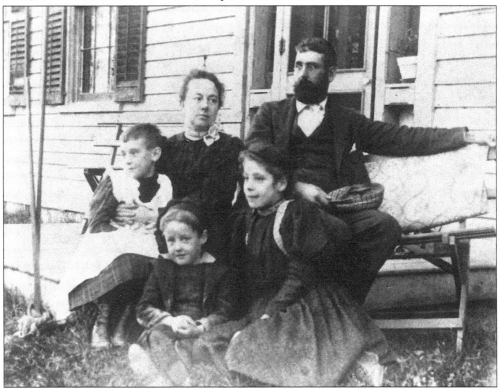

Frank and Bertha Hopson pose in 1891 at Lordship Manor, then their home, with their children: Grace, William, and Adaline. In 1896 Frank's brother William formed the Lordship Park Association.

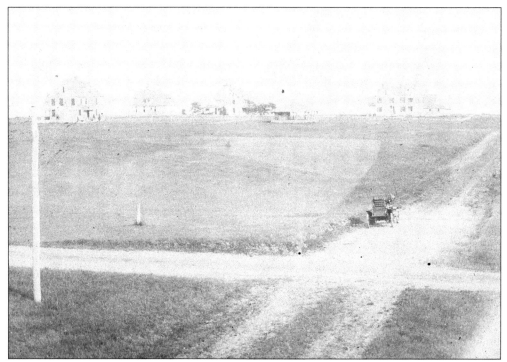

By 1896 the earliest homes graced the shoreline at the Lordship Park Association, a seaside residential park. William Hopson, president, saw to it that roads were cut, a golf course was built, and lots were sold. In 1911, a new corporation took over, built a pavilion, casino, and trolley line, and renamed the place Lordship Manor. Soon all of Great Neck became known as Lordship.

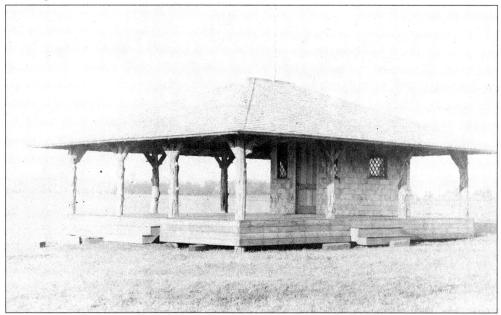

The golf club office at Lordship Manor on Ocean Avenue is shown as it appeared in the early 20th century.

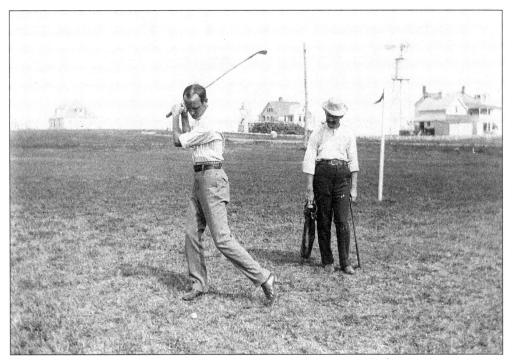

Horace Strong practices his swing at the golf club while a friend observes but makes no comment. This scene is at the corner of Pauline Street and Stratford Road looking toward Long Island Sound.

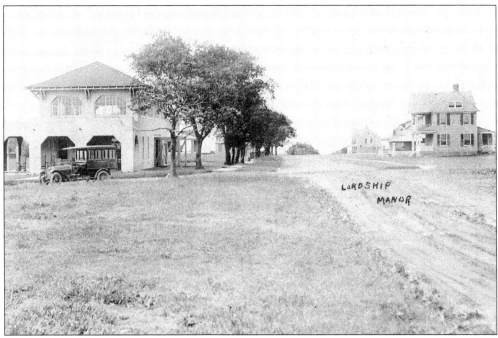

On summer weekends, Professor Quilty from Quilty's Studios in Bridgeport ran dances on the casino upper deck. Patrons refreshed themselves at the ice cream parlor below. Since the jitney bus is prominent in this view, the date must be after 1925.

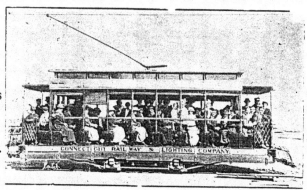

Cars Leave
Stratford And
Hollister Avenues
"Quarter After"
The Hour From
6 A.M. to 11 P.M.

Cars Leave
Stratford and
Hollister Avenues
"Quarter After"
The Hour From
6 A.M. to 11 P.M.

A GROUP OF "LORDSHIPPERS" ON THE NEW TROLLEY

"New Lordship Trolley"
Officially Opened Saturday

Saturday marked the formal and official opening of the new Lordship Trolley Line, which connects with the Bridgeport and Stratford Lines at Hollister and Stratford Avenues—and runs direct to Lordship Manor "On the Sound."

The occasion was celebrated by a dinner and reception which was attended by delegations of public officials and newspapermen of Bridgeport and Stratford. The executives of the new "Lordship Co." outlined their plans for the future of Lordship Manor as a real animated shore resort—not a "Coney Island" and not an "Ocean Grove," but a democratic watering place where congenial yet fastidious people of this section may enjoy their holidays or evenings. It is the intention of the management to provide various entertainment features from time to time —the number and extent of these, of course, will be governed largely by the measure of public support accorded the management in their efforts.

Bath Houses Ready July 1

Definite announcement was made as to the bath houses—Contracts have been signed with "bonus and penalty" clauses which provide a fine for each day after July 1 that the work is incomplete—hence bathers may well look forward to a "Fourth of July" bath at Lordship.

Over 100 individual houses will be provided and they will be equipped in most modern fashion—shower baths, retiring rooms and lavatories will be installed on both sides of the building.

A commodious lunch room, as well as an ice cream parlor and tea room will be located on the ground floor front—the upper balcony will be about 20x50 feet, which provides an observatory for spectators and non-bathers.

Many other refinements will tend to make this the finest bathing pavilion in this section.

Bridgeport's Newest And Best Resort Bids You Welcome

Public Dancing All Season

The public dance held Saturday evening under the direction of Prof. Quilty proved such a huge success that it was decided to continue these dances in the Lordship Casino all season or at least until a larger and more commodious hall can be erected on the shore front adjacent to the bath houses.

Definite announcements will be made with reference to the policy of the dancing pavilion—as well as the night or nights of each week that same will be open to the public.

A small fee will be charged—in all likelihood and the atmosphere will at all times be correct in every sense—no undesirable "spielers" will be permitted, and no rowdyism of any sort will be tolerated.

On the lower floor of the Casino is an ice cream and refreshment room.

Take A Trolley Ride To This Garden Spot

In the summer of 1915, with borrowed trolley cars, the Lordship Railway Company opened its 3-mile route across the marsh from Bridgeport to the new casino at Lordship Manor.

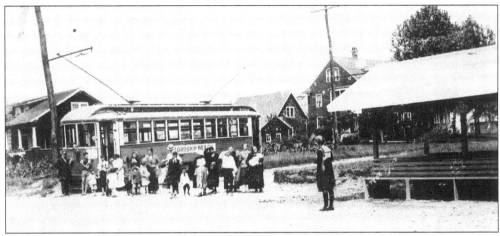

On summer weekends, open trolleys brought crowds to Lordship Manor, to the beach, the pavilion, the dance casino, and the golf course. Year-round, the Lordship Railway Company's closed car crossed the marsh every hour. On icy winter days, motorman Fred Biebel would remain on the roof to reconnect the trolley pole, while his conductor ran the car. In 1925 the line closed and was replaced by jitney buses.

In 1914 the weekly Stratford newspaper rewarded delivery boys by offering contest winners a week at the shore.

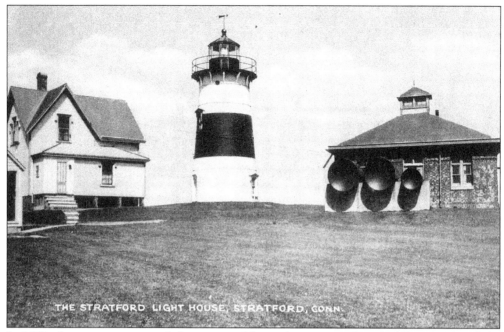

THE STRATFORD LIGHT HOUSE, STRATFORD, CONN.

In 1881, the present cast-iron light tower and keeper's cottage at Stratford Point replaced the original buildings built in 1821. In 1911 a compressed air-powered Typhon horn replaced the old crank-wound bell. In some weather, keeper Theo Judson's diaphone could be heard across the Sound.

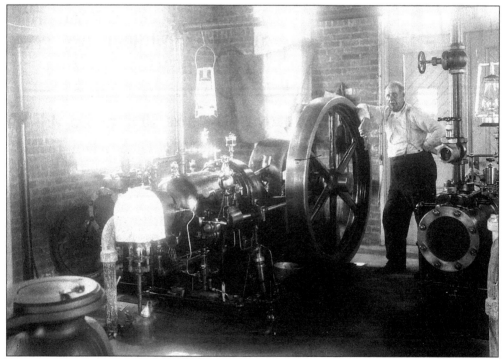

Inside the fog signal station two air compressors driven by two electric motors stood in 1911. Lighthouse keeper Theo "Crazy" Judson was not bashful about discussing his mermaids.

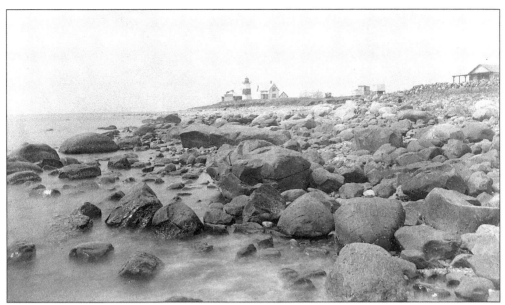

Stratford Point juts out a mile beyond the rest of the Connecticut coast. At low tide rocks dumped by the last glacier are visible. On the right, buildings of the Remington Gun Club wait for skeet shooters to arrive. Over many years so many lead pellets have fallen into the inter-tidal waters that the State Department of Environmental Protection has proposed a massive cleanup.

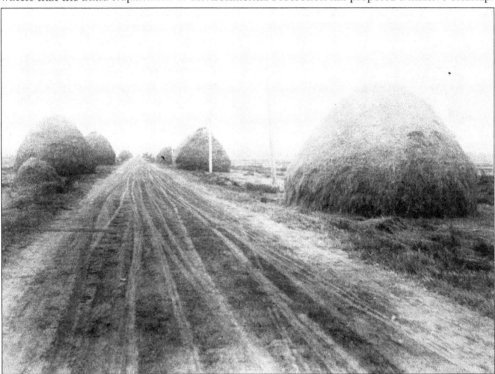

A century ago, agricultural Stratford depended on salt hay from Great Meadows and river marshes. Haystacks appeared in the late summer, to be left all winter for nearby farmers or transported by wagon or barge to more northerly farms for use as animal bedding and forage.

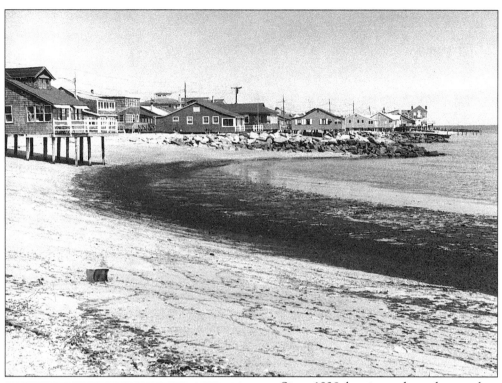

Since 1938, hurricanes have destroyed
cottages and worn away the shore.
Rock groins have reduced erosion, but
supporting pilings still look longer every
year. Shore cottages on pilings at Long
Beach are vulnerable to hurricanes and
storms.

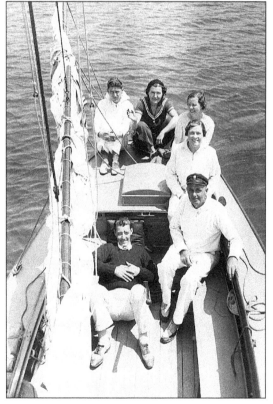

Alfred Birdseye Beach stretches out
in the cockpit of his sloop *Polly* at the
Housatonic Boat Club in the summer
of 1935. Al's crew included his wife,
Alice, Aunt Ethel Beach Wales, Dorothy
Wheeler Trimingham, and Charles
Crosley.

Seven

THE NORTH

Looking north toward Paradise Green in the early teens, we find Main Street and Huntington Road unpaved. A trolley brings passengers up Main Street from Bridgeport and Stratford Center. Grocers, butchers, and fruit peddlers drove their wagons through each neighborhood on scheduled routes, ringing bells to announce their arrival. There were no stores yet—they would come later.

Ox Pasture Lane led through Wilcoxson's property from Main Street at the Green to East Main Street and Harvey's Farm. Near the bottom of this hill the U.S. Army held its first maneuvers using aircraft in August 1912. It is now called Wilcoxson Avenue. On the left is the site of Wilcoxson School.

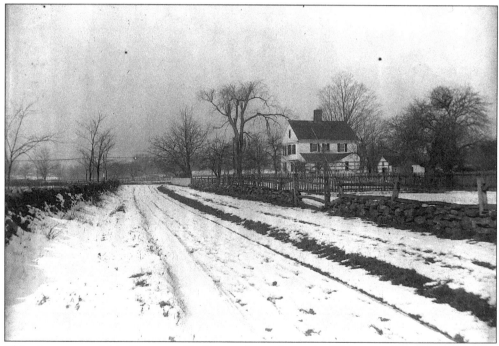

This view west to Main Street on Ox Pasture Lane shows the Wilcoxson Farmhouse standing alone. In the 1920s the house was moved to become the first house on the north side of Wilcoxson Avenue.

94

With motorcars increasing in number, this spot at Peck's Mill on the Housatonic River became an ideal restaurant location. By 1927 a new concrete highway had been built where the trolley line formerly ran, and the Housatonic Lodge served lunch and dinner to passing motorists.

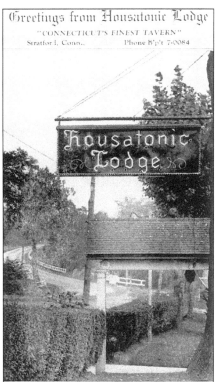

When business expanded at the Housatonic Lodge, so did the lodge itself. In 1927, the original eating house is hardly visible behind the large addition. For many years the Housatonic Lodge was the most popular catering house in town. Its riverfront lawn held wedding receptions all summer long. Renamed the Raven in the 1960s, the restaurant burned to the ground and was never rebuilt.

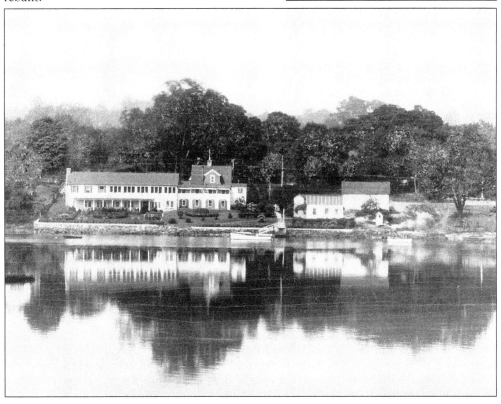

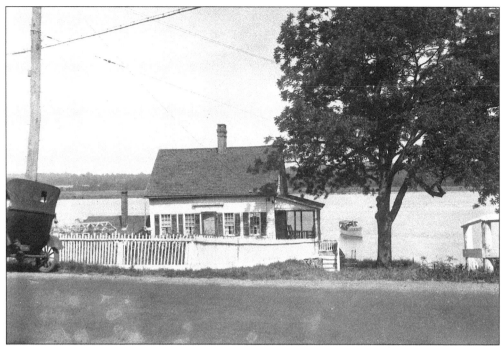

Across the street from where the icehouse stood at Peck's Mill Pond, a public right-of-way still runs down to the Housatonic. In 1920 Benjamin's cottage was one of several built along the shore, where townfolk came to find summer breezes.

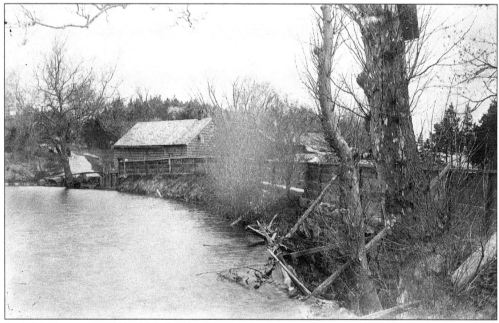

In 1898 Treat and William Peck sold their gristmill, sawmill, and the pond. This view looking north along Main Street in 1910 shows the two mills across the road, and the water gate at the pond for filling the sluice and turning the wheels. Beyond the mills, the gravel road continues up the hill and on to Putney.

Looking south, beyond the canopy of trees at Peck's Mill stands the little house that became the Housatonic Lodge. To the left, Pumpkin Ground Brook tumbles toward the river. To the right is a shed covered with advertising of a Bridgeport clothing store and, beyond, is Peck's icehouse.

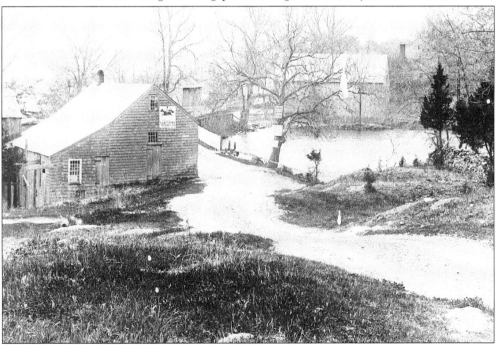

This view of Peck's Mill dates from the early 20th century, based on the highway advertising sign posted on the building. As the volume of motor vehicles grew, more signs appeared on the mill, until it was torn down c. 1913. The icehouse is located across the pond.

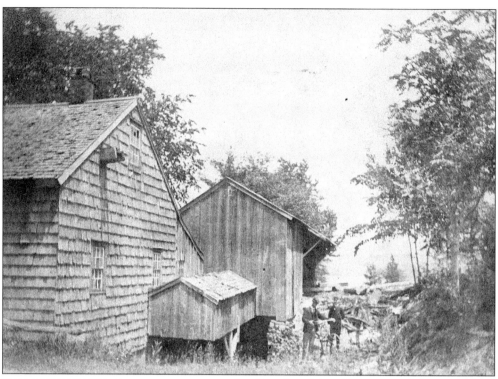

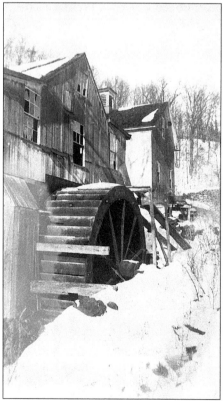

Looking from Main Street toward the river, the mills at Peck's Mill Pond are lined up along the millrace. The gristmill in the foreground shows its undershot or breast wheel, covered by a spray shield. The sawmill beyond was built in the 1816–1833 period by David Wheeler. Its wheel was apparently located below the roof extension seen in the photograph.

The fall of Pumpkin Ground Brook at the inlet to Wheeler's Mill Pond, as Peck's was called in 1830, was ideal for a mill, so Abraham Lewis leased the land to build a flax mill. It operated as a fulling mill, and later as a factory manufacturing celluloid combs. This photograph shows an abandoned mill, the millrace gone, with a storehouse/barn above it. The dam was finally washed out by a mid-20th century hurricane.

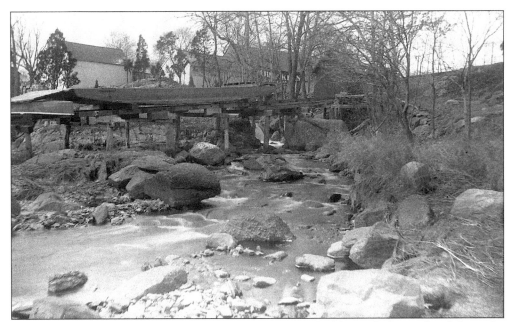

Below the spillway at Peck's Mill Pond a short stream dashed beneath the road and down the rocks to the river. Stored on pilings next to the brook, one of the last hay scows waits a for launching that will never come.

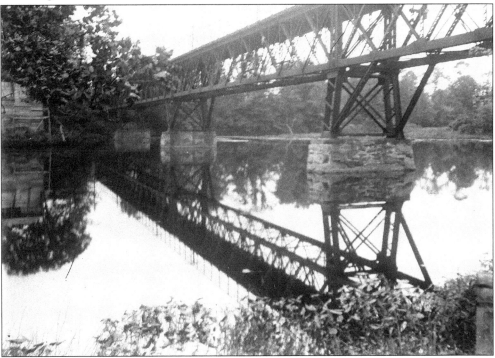

In 1899 the Shelton Street Railway Company built a trolley line from Stratford. Soon this line became part of the Bridgeport Traction Company, and then Connecticut Railway and Lighting, which operated until replaced by buses in 1927. The bridge across Peck's Mill Pond was its most extensive structure. One of the piers is still in the pond.

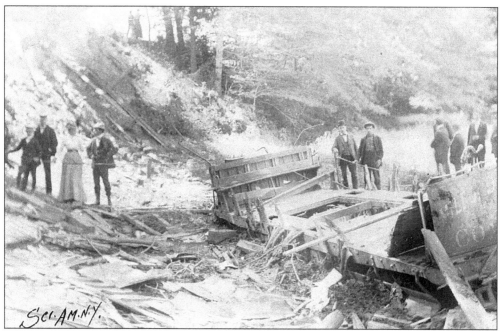

The trolley line to Shelton opened on August 3, 1899. Three days later, disaster struck. An open car with hand-operated brakes set out with 40 excited excursion passengers. The approach to the Peck's Mill Pond Bridge was 700 feet of downgrade, and the new roadbed was rough. The car was doing 30 miles an hour when it hit the bridge. It bucked and swayed, left the rails, bobbed along the ties, and plunged into the pond, landing on its roof. The motorman jumped to safety, but 32 passengers died.

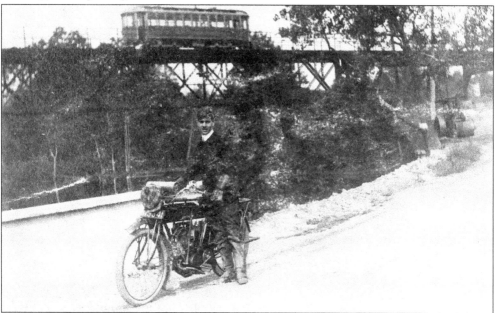

The rambling road to Oronoque was dusty, rough, and bumpy. Raymond Bassett poses at Peck's Mill Pond in 1914 as a steam roller rests in the background. The trolley from Derby proceeding onto the Peck's Mill Pond Bridge offered an easier way to travel.

When Miner Knowlton sold off Knowlton Park, the Weatogue Country Club lost its golf course, so its members moved to an old farm at Main and East Main Streets. The club reopened in 1916 on Decoration Day with a nine-hole golf course and tennis courts.

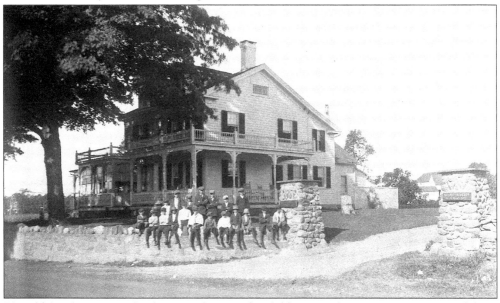

The old farmhouse at Columbus Farm became the clubhouse at the Weatogue Country Club. In 1923 the club was renamed the Mill River Country Club. Tom Winton laid out a new 18-hole course and the first foursome teed off in September 1926. A group of caddies sits in front of the clubhouse, which was used until the 1950s.

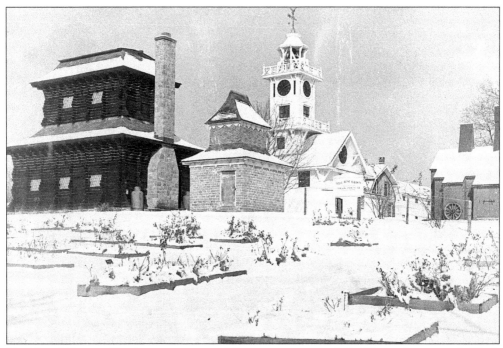

David and Steven Boothe spent years adding structures to their 30-acre homestead. Their "technocratic cathedral," built in 1933, was a monument to the Great Depression according to David. It was built with flat timbers (like Depression finances) and redwood (like Depression ledgers). The multi-sided blacksmith shop has been operable since 1935. The clock tower was added to the carriage house in 1913 and has recently been refurbished.

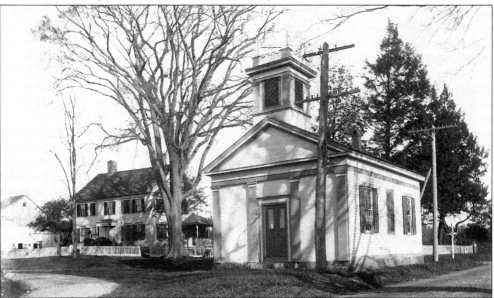

Putney Chapel was built in 1844 to provide services and prayer meetings for area residents. It stood at the intersection of Main and Chapel Streets. When passing motorists began to hit the building, it was time to move it. In 1968 Putney Chapel was moved just across the street to Boothe Park and in 1985 the first wedding in many years was held here.

When Main Street Putney was a country road, farmers added large verandas to their Colonial houses in order to enjoy the shade on summer Sundays, and built their barns and outbuildings close to the road to challenge winter snows.

The road through Putney passed several multi-generational homesteads belonging to the Wheelers, Boothes, Welles, and others. The Boothe home on the right became town property when David Boothe died in 1949, and is now a unique town park and museum. In the distance, Putney Chapel is visible.

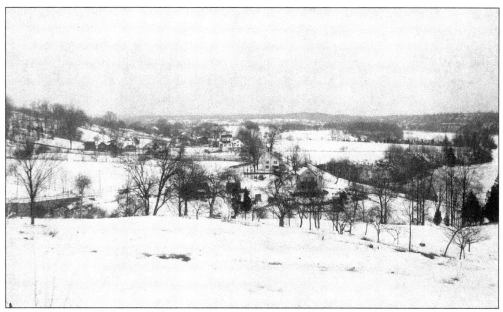

From the top of Skidmore Hill in Putney in 1900, the Housatonic Valley stretches out. From the left, the river road heads toward Shelton, and from the right, the trolley line descends to meet it. In the distance the Farmill River forms the town line.

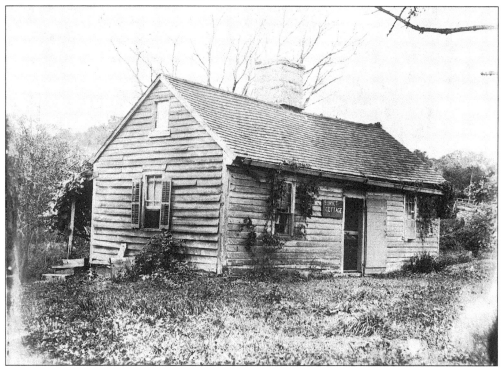

It was called the oldest house in Stratford, and it may have been. "Sunset Cottage" was built in the 1600s, possibly by Ephraim Stiles, and must have housed slaves of the Nodine family. On a brook called Nigger Brook, now Freeman Brook, it evolved into a quaint early-20th-century tearoom, and was finally torn down.

The 1910 Connecticut Manual lists fishing and farming as Stratford's major industries. Here, spraying for potato beetles in Oronoque is made easy. As the wagon passes down the rows, farmers pump their arsenic or Paris Green onto the emerging plants. The yellow larvae would eat the leaves and die while the potatoes remained uncontaminated underground, allowing the farmers to sell them at a profit.

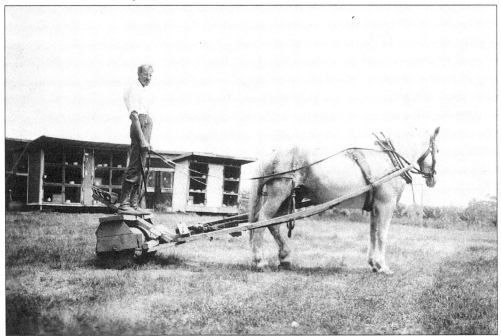

Before tractors became widely used, a springtime job after the first fertilizing and plowing was harrowing. Here a disk harrow, with Frederick C. Booth standing on it to add weight, is cutting up the winter rye (the poor man's green manure) planted the previous autumn. The cow manure and plant remains, with an added chemical fertilizer (5-10-5), would bring a healthy crop.

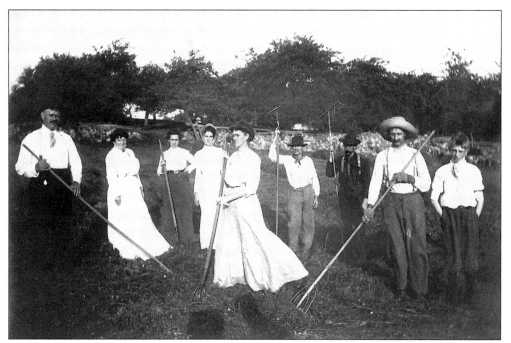

What is wrong with these pictures? Normally, farmers used a horse-drawn hayrake to gather hay. Sitting on a steel seat mounted on a single leg and guiding the horse with reins while continually raising the tines with a foot lever to unload the hay was no easy job. Men with hayforks would then load the haywagon 10 feet high.

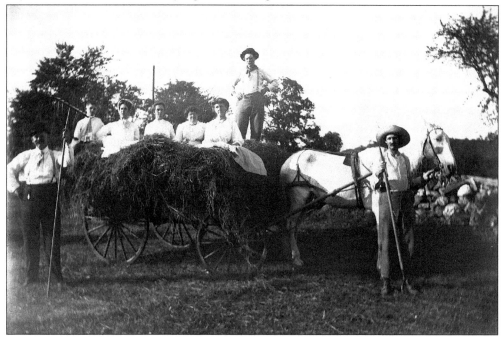

Half of these people are women, however, and lawn rakes are being used to gather up the hay. In addition, there is only a 2-foot blanket of hay in the wagon. The answer is obvious—tonight would be a harvest moon, and they are getting ready for a hayride.

106

Five miles north of the Center, Oronoque Village in the early 1900s was an active small community with its own stores, school, and post office. This photograph, taken from the trolley line that ran through Oronoque on Main Street, shows the rockers on the post office porch, where residents exchanged their news and views.

Looking south from Oronoque, the road up Skidmore Hill was a difficult pull for a loaded team. This group may be waiting to have the horses shod by the farrier at Johnson's Smithy (off the photograph to the left).

This pastoral view from the piazza of Wellesmere marks the 20th-century location of the Unitarian Universalist Church on Chapel Street.

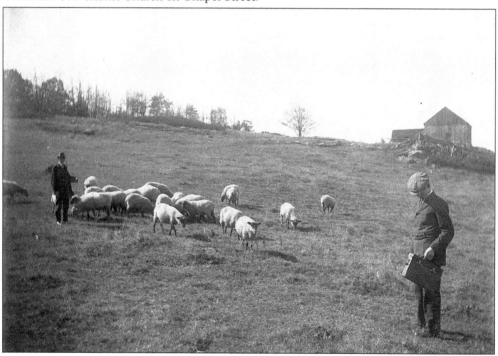

Howard Wilcoxson spent his youth driving around the Housatonic Valley with camera in hand, recording pastoral scenes. We do not know where this scene was recorded, but it represents the countryside from Stratford to New Milford in the early 20th century. The young man with the camera is probably Howard Wilcoxson. Who snapped his picture?

Eight

OUR STRATFORD COMMUNITY

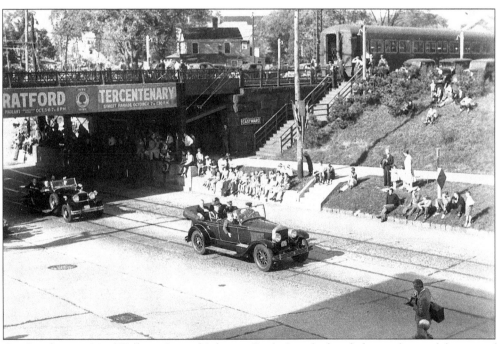

On October 7, 1939 (William Samuel Johnson Day), Stratford ended a yearlong celebration of three centuries of history with a big parade featuring 2,000 people, 23 floats, 9 military units, and the governor's foot guard. Gov. Raymond E. Baldwin and his Stratford family rode to the ceremony at Academy Hill in an open touring car, followed by our last surviving Civil War veteran, Truman Parsons, in another.

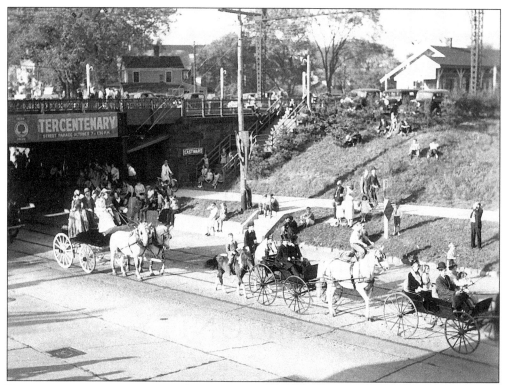

Every remaining carriage, cart, and wagon was pressed into service and every old costume was dug out of trunk or closet to celebrate the end of three centuries, the end of a long depression, and the beginning of a new era.

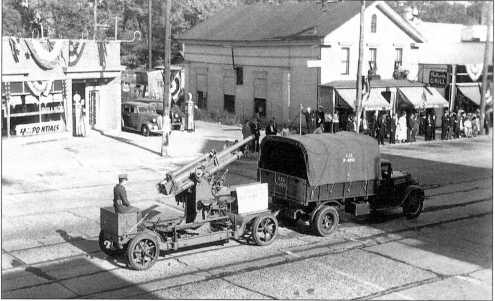

During the 1939 Stratford Tercentenary Celebration, Battery B's anti-aircraft gun moves past the very spot where, on August 10, 1912, the U.S. Army Flying Squadron had towed three aircraft to fields at Paradise Green for the Army's first-ever operational use of aircraft.

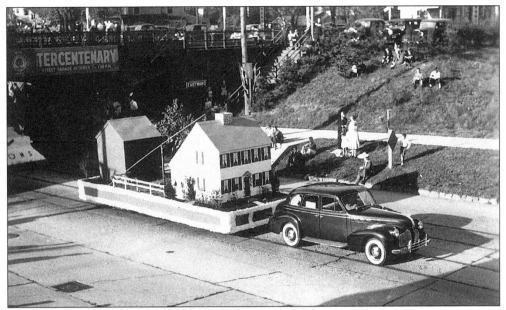

A brand new 1940 Pontiac tows a float bearing a model of the ancient Dayton House. The lean-to (saltbox) house, usually facing south, was universal in the early 18th century, and in 1939 many still existed. Since then most have been destroyed to make way for modern homes or commercial buildings, and today only a handful remain.

In 1925 our growing council-manager government called for a new, larger town hall to replace the 1875 brick building in the Center. Designed by Stratford architect Wellington Walker, it was of neo-Colonial design and projected to cost $185,000. Depression delayed construction for years, but finally the new town hall opened for business on February 1, 1937. Local politicians accepted 45% of the final cost of $194,098 from the federal government.

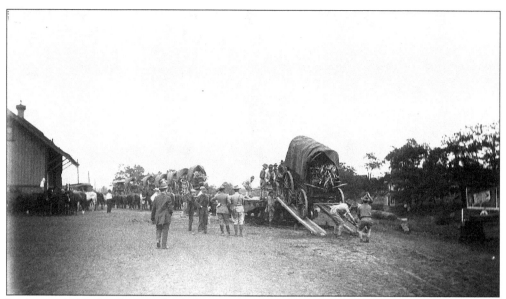

In August 1912, the Army unloaded its supplies at the Stratford railroad freight yard to set up an encampment east of Paradise Green. Ten thousand men would be involved in Army war games, as the Blue army defended New York City from the Red army across the Housatonic in the most extensive practice maneuvers ever undertaken.

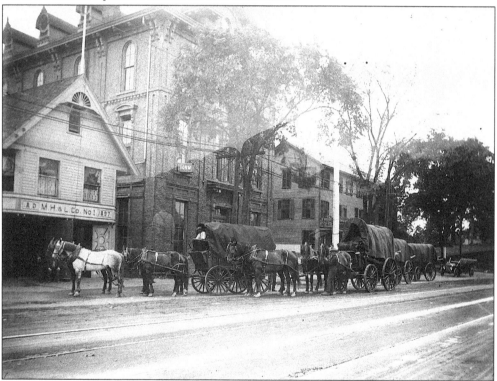

Army mules were used to pull supply trains to the Blue army headquarters encampment on Wilcoxson's farm. Lined up in front of the firehouse (Mutual Hook & Ladder Co.), the town hall, and Newton Reed's block, they wait for orders.

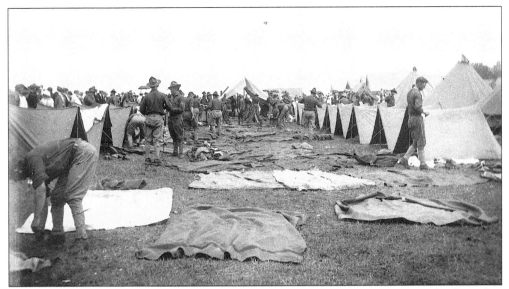

A 5,000-man Blue army set up camp in Stratford in 1912 near where Wilcoxson School is today. Army maneuvers lasted until the attacking Red army, based across the Housatonic, defeated the Blues. Brig. Gen. Tasker Bliss ran the exercises, observed by U.S. Army Commanding General Leonard Wood and several European officers. A tent reserved for President Taft went unused.

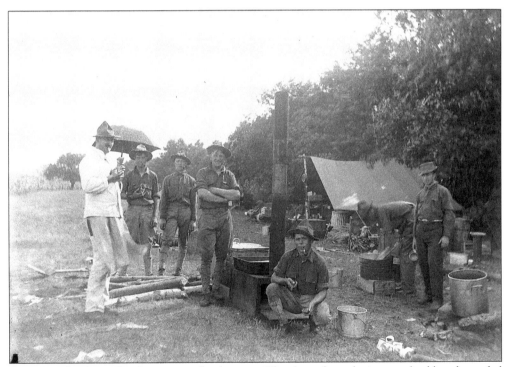

Oats were for the mules, beans were for the men. The Army brought its own food but depended on local wood for fuel. This outdoor kitchen at "Camp Walter Lee" in 1912 shows the whole scene—an iron cookstove, buckets for water, a cauldron for mess, a washtub and washboard, and a shovel for latrines.

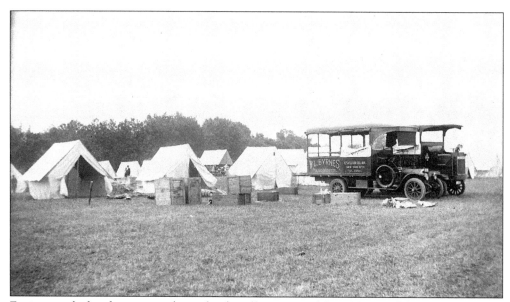

Equipment for headquarters and gear for the officers arrived from New York by truck at "Camp Walter Lee" in Stratford in August 1912, while Brig. Gen. Tasker Bliss arrived at the Pootatuck Yacht Club by launch to oversee the exercises.

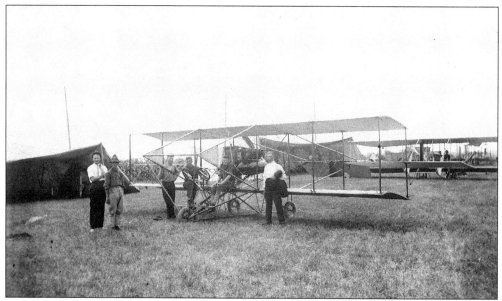

The U.S. Army first used aircraft at its Stratford war games. This Curtiss bi-plane, the Wright Model B in the background, and a Burgess formed the fleet of the Army Flying Squadron. Beckwith Havens damaged the Curtiss in landing, and Lt. Benjamin Foulois, landing in Botsford to send a telegram when his airborne wireless failed, was captured by the Blues. Aerial reconnaissance, however, had been proven. Foulois became a major general, commander of the Army Air Corps, and the country's oldest living military aviator.

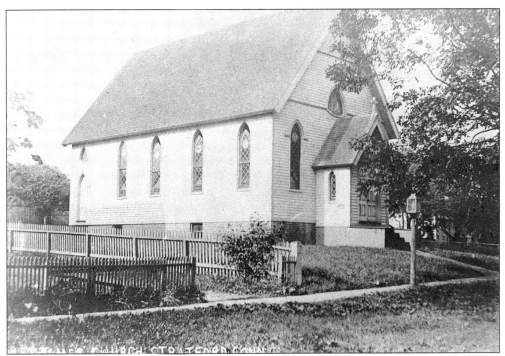

Prior to 1886, Catholic immigrants walked to Bridgeport to attend mass. St. James Church was the first Roman Catholic Church in town. When it became a separate parish in September 1906, its chapel, next to Hamilton's stables on Broadbridge Avenue, was already full. On May 17, 1914, the large brick church on Main Street was dedicated. The building in this photograph has since been home to several denominations, but has always been used as a church.

In 1902, member Elliott Peck, a financier by career but architect by training, designed this building for the First Methodist Church to replace the Greek temple that had been their home since 1839. It was a typical American church building of the period. The elm trees planted by Hamilton Burton in 1840 remained in place, as did the parsonage. In 1966 this church was torn down to make way for a larger modern facility.

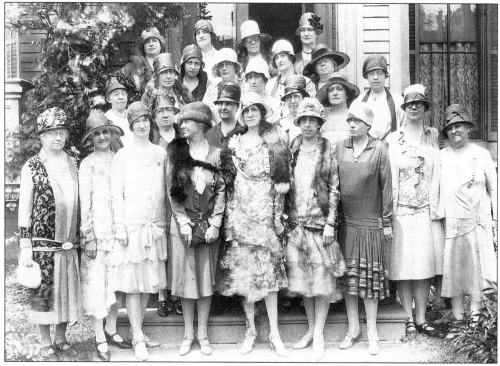

This formidable phalanx of ladies represents the Woman's Service League of the Congregational Church in the 1920s. Mrs. George W. Zink (second from left, third row) and Mrs. Edmund Judson Sr. (far left, front row) were president and first vice-president in 1929. Mrs. Charles Silliman (third from left, second row) bought her hats from Mrs. Halligan on Fairfield Avenue in Bridgeport.

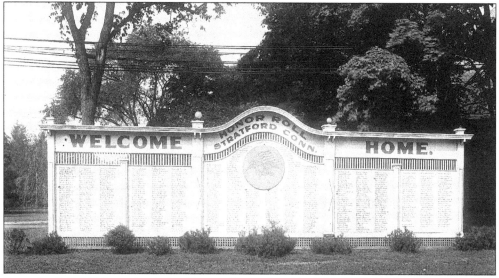

From April 6, 1917, to Armistice Day on November 11, 1918 (585 days), Stratford sent its sons to war. Thirteen did not return. This honor roll on Main Street near the Congregational church listed the 508 names—one in every 20 residents. In 1931 it was replaced by a statue of a seated lady, dedicated to peace, at South Parade.

In the early 1900s Rev. Seymour Bullock organized the Neighborhood Church of Christ on Church Street. When interest waned, the building was taken over by the Okenuck Tribe of the Independent Order of Red Men as their meeting hall. It became a neighborhood center for concerts, dances, and plays. Its final use before demolition to make way for the Turnpike (I-95) was as the first Polka Dot Playhouse, when it was painted to match the theme.

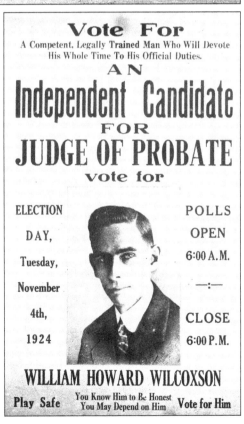

Vote For

A Competent, Legally Trained Man Who Will Devote His Whole Time To His Official Duties.

AN

Independent Candidate

FOR

JUDGE OF PROBATE

vote for

ELECTION DAY, Tuesday, November 4th, 1924

POLLS OPEN 6:00 A.M.

—:—

CLOSE 6:00 P.M.

WILLIAM HOWARD WILCOXSON

Play Safe — You Know Him to Be Honest You May Depend on Him — Vote for Him

William Howard Wilcoxson, a descendant of one of the area's first settlers, dedicated his life to Stratford. In 1924, at age 28, he made his only run for political office but lost to a John Smith. Howard wrote the history of the town in 1939 and updated it in 1969. He recorded Stratford with his camera and is in the cover photograph of this book. He served as town clerk for 32 years.

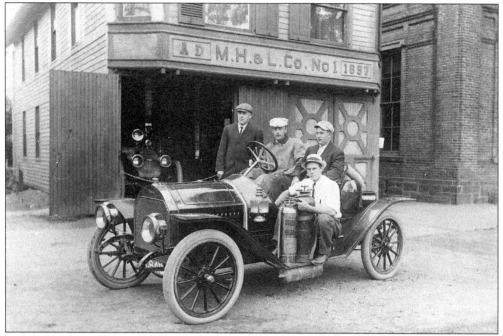

This 1911 picture shows "Everything's up-to-date in good old Stratford." In 1909 the volunteer fire department became the Stratford Fire Department and Allan Judson became its paid chief. A new Locomobile hook and ladder peers out the door, although the horse-drawn hook and ladder had not yet been retired. Volunteers George Webb, Joe Johnson, Shorty Lines, and Deak Clinton are ready to do duty in the new Patterson 30 auto.

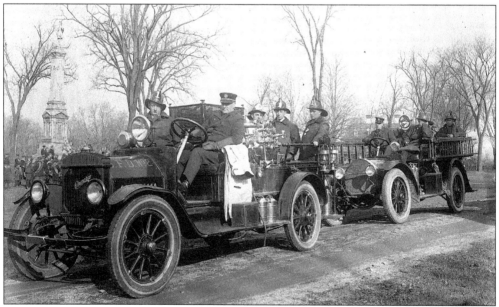

At the formal opening of the new Washington Bridge on Armistice Day in 1921, Stratford and Milford each organized big parades that met at the middle of the bridge. Chief Judson takes command of the fire department's new Engine No. 2, followed by Hook and Ladder No. 1, as the parade organizes at Academy Hill.

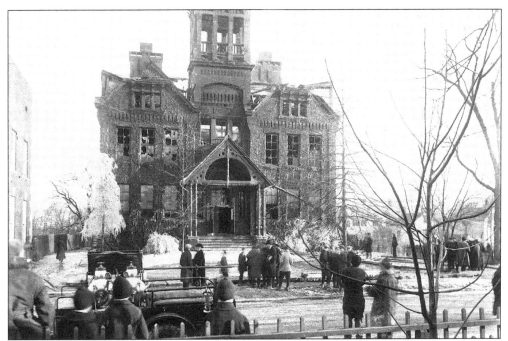

When the Stratford Graded School opened in 1885, architect Rufus Bunnell was praised for the impressive building. On the frigid night of February 19, 1921, the school went up in flames. Although the fire department was just down the street, the fire was so fierce that nothing could be done to save the building.

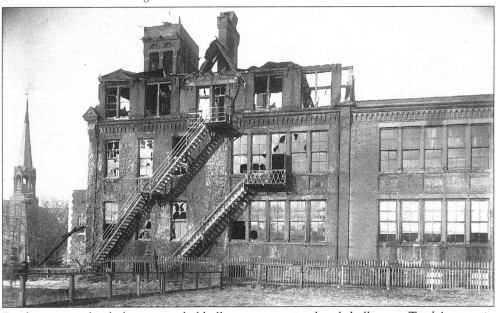

For four years school classes were held all over town—in church halls, over Tuttle's store, in vacant stores, and at the theater—while architect Wellington Walker was commissioned to design a new low-cost high school. That school opened in 1925 and the Graded School was rebuilt as two-story Center School. Since 1969 it has been the office of the Stratford Board of Education.

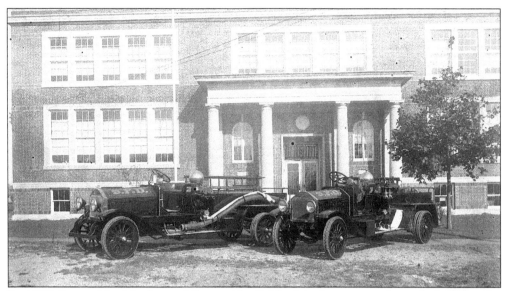

By 1927, Engine No. 3 had joined Engine No. 2. No. 3 had a siren in place of a bell, but the two were otherwise identical. This photograph in front of Nichols School was taken across the street from Firehouse No. 2, a one-stall engine house with a clubroom overhead.

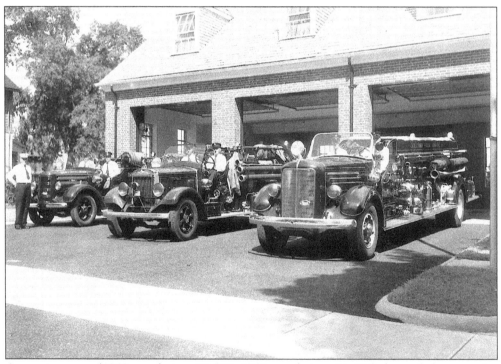

A growing town (1940 population: 22,580; 1950 population: 33,428) demanded greater fire protection. After the new town hall was built, a new firehouse was added in addition to new more powerful engines (shown here). Today the new six-story tower engine and other new equipment have made expansion of the department necessary.

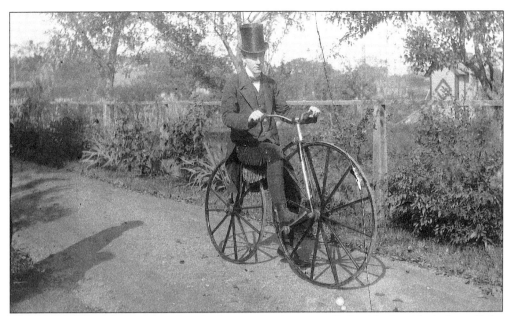

The first true bicycles used in Stratford, two wheelers propelled with the rider's feet off the ground, were appropriately named "boneshakers." Their iron frames and wooden wheels sent road shock directly to the rider. Riders wearing top hats and tails were called dandies. Invented in Paris in 1861, boneshakers remained a fad. This unidentified rider was photographed by Frederick Beach.

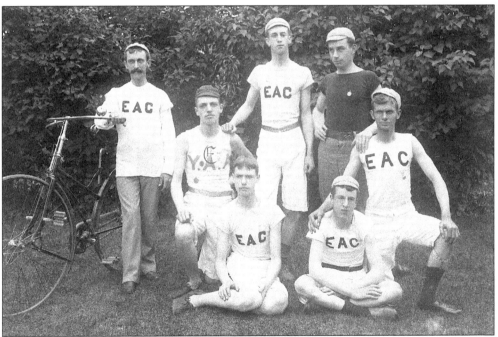

George Fryer holds his new safety bicycle but the other Eagle Athletic Club members are ready to sprint in this c. 1891 photograph. Seated are Frank Bunnell and Rob Wheeler. Kneeling are Frank's brother, Sterling Bunnell (proudly wearing his Yale Athletic Association shirt), and Rob Blakeman. Standing are Lewis Russell and Ed Beers.

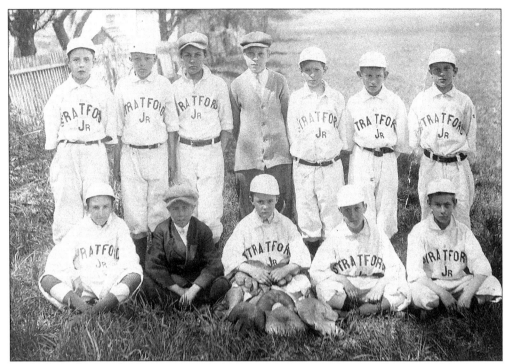

By the time the Stratford Juniors paused for a team picture in 1912, sandlot baseball had grown into an organized league, long before the modern "little league" began.

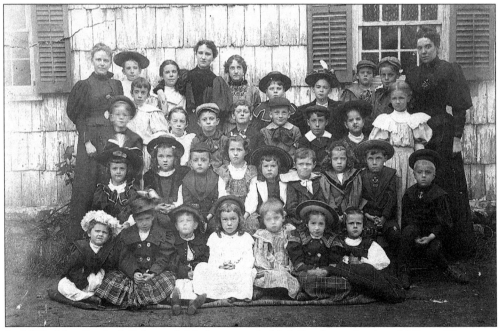

In 1895, Mrs. Rexford Delacour's kindergarten held daily classes in the old Perry House on West Broad Street. Mrs. Delacour (last row, right) taught the older kindergartners and Miss Laura Wood (last row, left) taught the very young. Mrs. Delacour's son, Rex Delacour, later General Delacour, is second from the left in the last row.

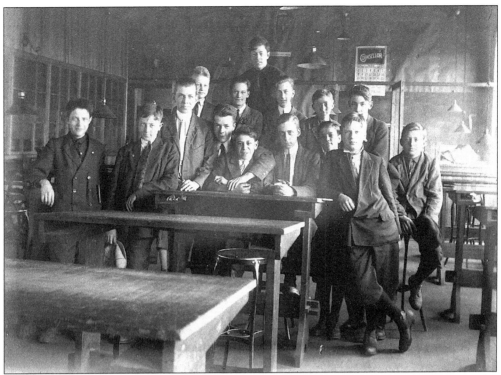

In 1918 the Housatonic Shipbuilding Company had six 2,500-ton wooden freighters on the ways. These young men were probably the whole drafting room team.

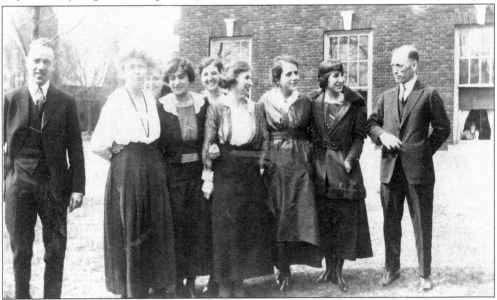

The nine-person high school faculty of 1920 poses in the front yard of the Stratford Graded School. The teachers are Mr. Nourse, Miss Phelps, Miss Day, Miss Palladino, Miss Avery, Miss Wilber, Miss Wilcoxson, and Miss Bugbee. Unmarried women were much preferred as teachers. Principal Wentworth W. Rogers, on the right, was at the beginning of a long career. The salaries of the faculty totaled $11,470 in 1920.

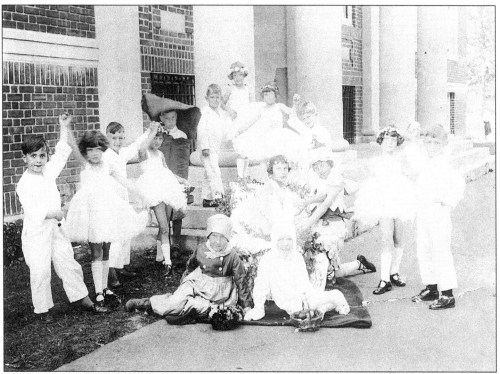

The June 1925 Spring Pageant at Garden School was entitled "Sweet Spring Awake So That I May Awaken Too." In the center, Edith Wheeler and Mary Lyons represent Spring and The Rose. The school is now gone and Senior Citizen housing occupies the site.

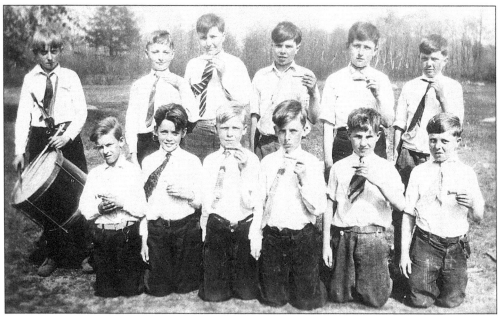

These 1930 Eli Whitney School sixth graders are all dressed up for a harmonica and drum concert. Does this group suggest an idea for today's musicians?

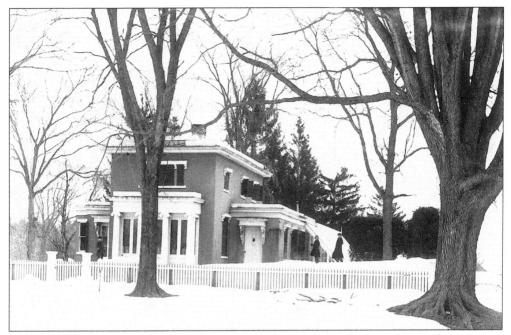

In 1855, Alfred Ely Beach, inventor, patent attorney, and publisher of *Scientific American*, bought "the Yellow Cottage" on Elm Street and began development of an estate. When Beach died in 1896, the family owned 15 acres and a yacht club. This winter picture of the Yellow Cottage, now 1670 Elm Street, shows the greenhouse attached to the house.

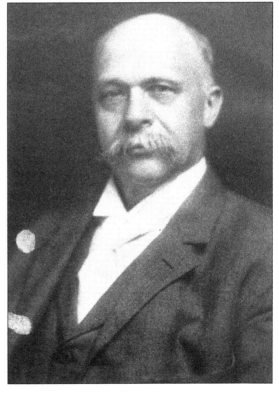

Frederick Converse Beach was one of the first amateur photographers of note in America. Before 1868 he set up his first photography shop at his father's house on Elm Street. A personal friend of George Eastman, Beach helped found the Camera Club of New York in 1884, then began and edited *American Photography* magazine. In 1902 he became editor-in-chief of Encyclopedia Americana. After his father's death he inherited part ownership in *Scientific American* magazine.

The adults in the Beach family were not the only ones to enjoy the latest mode of transportation. This scene of Margaret Beach on the walkway in front of her grandfather's home (the Dowdall/ Phelps Mansion) shows the youngest generation enjoying (?) her Irish Mail.

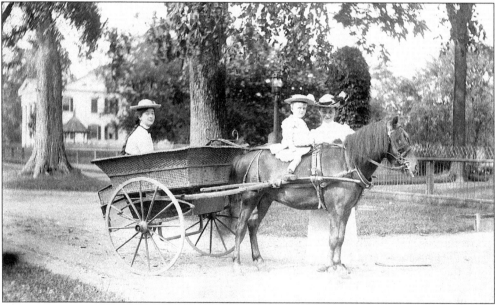

In the pony cart and astride the pony, young Beach family members pose with their mother standing by in front of their grandfather's home on Elm Street with its intricate wrought-iron fence.

Alfred Beach, born in 1900, reads his book in the Victorian parlor of the home at 1813 Elm Street. His dog waits patiently for playtime.

Looking north on Main Street toward Stratford Center in 1908, Frederick C. Beach took this picture of his grandsons, Alfred Birdseye Beach and Frederick Converse Beach.

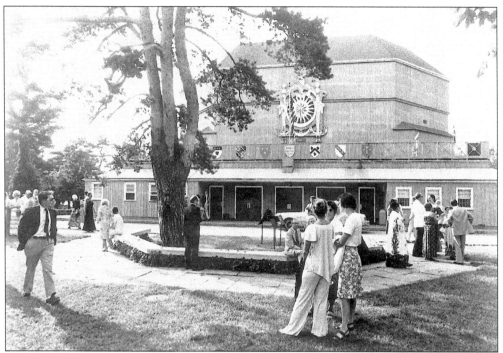

By the 1970s the Shakespeare Festival Theatre in Stratford was a national Shakespeare shrine. From all over the country patrons came to view the plays in the avant-garde theater begun by Lawrence Langner in 1955, dramatically developed by John Houseman, and artistically refined by director Michael Kahn. Commended for imaginative productions, the company lost money nevertheless, and closed its doors in 1982. A new attempt to revive it is underway in 1999.

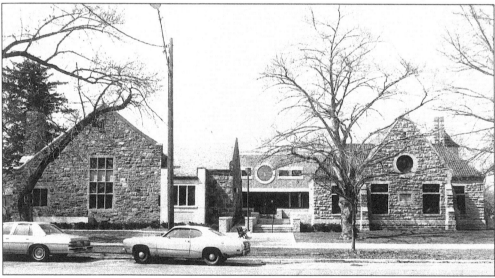

After 80 years the Stratford Library Association elected its first woman president. Vivienne Knapp and her library board were able to persuade a reluctant town council to sponsor a vast library expansion. By planning to combine the library building with the under-utilized Sterling Memorial Community Building, the library board at moderate cost achieved this modern library/cultural center for the town. The new library opened in 1979.

128

CPSIA information can be obtained
at www.ICGtesting.com
Printed in the USA
BVHW010611171218
535781BV00016B/162/P